BIG BOOK OF
Pyrography
PROJECTS

**Expert Techniques and 23
All-Time Favorite Projects**

Editors and Contributors of *Pyrography* Magazine

Pyrography Magazine
www.PyrographyOnline.com

FOX CHAPEL
PUBLISHING

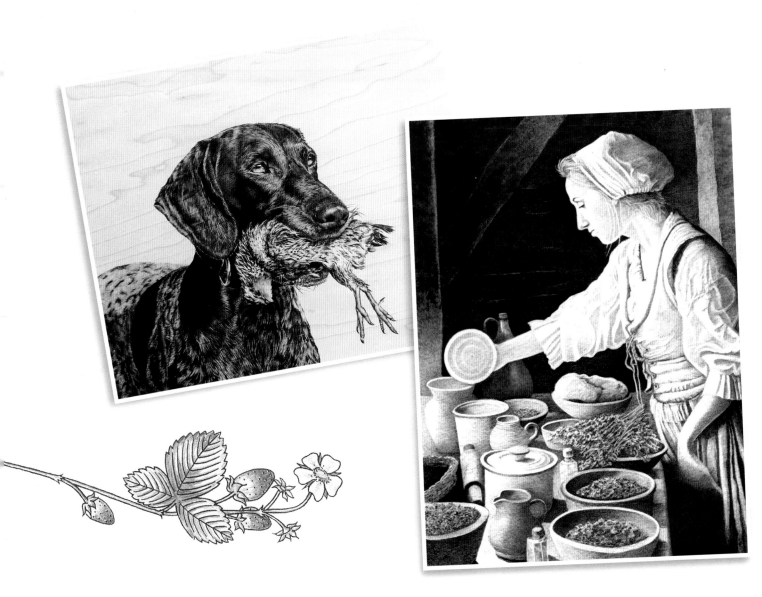

Big Book of Pyrography Projects is an original work first published in 2016 by Fox Chapel Publishing, Inc. Portions of this book were originally published in *Pyrography* magazine. The projects and patterns contained herein are copyrighted by Fox Chapel Publishing and the authors. Readers may make copies of these patterns for personal use. The patterns themselves, however, are not to be duplicated for resale or distribution under any circumstances. Any such copying is a violation of copyright law.

ISBN 978-1-56523-888-6

To learn more about the other great books from Fox Chapel Publishing, or to find a retailer near you, call toll-free 800-457-9112 or visit us at *www.FoxChapelPublishing.com*.

Note to Authors: We are always looking for talented authors to write new books. Please send a brief letter describing your idea to Acquisition Editor, 1970 Broad Street, East Petersburg, PA 17520.

Printed in Singapore
First printing

INTRODUCTION

Pyrography magazine is proud to present this collection of some of our best projects for pyrographers of all skill levels. Whether you're a complete beginner or an expert; whether you enjoy burning portraits, landscapes, or abstract designs; whether you like to burn on wood, paper, or gourds; you're bound to find just the right project in this book.

This book contains over 20 projects, as well as tips and techniques from many of our contributors that we hope inspire you to try both these projects and your own creations. For instance, master pyrographers Sue Walters and Lora Irish share tips on staying safe while burning and keeping your woodburner clean, while Danette Smith, Doris Lindsey, and Chris Wallace offer just what you need to create your own patterns from photos, stamps, and stencils. The gallery of projects from artists all around the world will encourage you to get creative and test your own ideas.

We hope this collection allows you to improve your woodburning skills and create beautiful pieces to keep or to give as gifts.

—The Editors

CONTRIBUTORS

Tracey "Scorch" Annison is a computer programmer who loves to decorate wooden and leather items with pyrography in her spare time. Tracey lives in London, England. See more of her work at Scorch's Pyrography, www.scorchpyro.co.uk.

Nedra Denison is retired from the Department of Veterans Affairs and has been woodburning since the early 2000s. Nedra is a self-published author of pyrography books and runs an extensive website which includes materials and supplies for the pyrographer. Visit her website at www.nedraspyrography.com.

A former wildlife rehabilitator and commercial photographer, **Cheryl Dow** has over 20 years of pyrographic experience, specializing in animals, birds, and scenic projects. Cheryle loves to teach and has published numerous books, magazine articles, and DVDs. Visit her website, www.cherlyddow.com, for a variety of resources.

Simon Easton studied woodturning, silversmithing, and pewterware in college, and now applies his knowledge to creating pyrography art with a contemporary twist. Simon is the author of *Woodburning with Style*, available from Fox Chapel, www.foxchapelpublishing.com. See more of Simon's work at www.woodtattoos.co.uk.

Best known as a calligrapher, **Joanne Fink** is also a teacher, speaker, designer, mentor, and author. Her studio, Lakeside Design, specializes in developing inspirational and faith-based products for the gift, stationery, and craft industries. Joanne's Zenspirations® designs are available on greeting cards, rubber stamps, stencils, t-shirts, wall decor, and other gift and stationery products. Visit www.zenspirations.com for more information.

The author of *Great Book of Woodburning* and many other titles, **Lora S. Irish** is a regular Fox Chapel Publishing contributor. Lora and her husband, Mike, created a web-based studio of tutorials, projects, and patterns for crafters and artisans, including lessons and patterns specifically for pyrographers. Learn more at www.carvingpatterns.com.

Doris Lindsey is a self-taught artist who has been creating various forms of art since childhood. She has been carvign wood and doing pyrography since the late 2000s. Although she currently lives in Oakwood, Ga., Doris is originally from Long Beach Island, N.J. Because she grew up near the sea, she enjoys coastal themes. See Doris's work at Fine Art America (www.fineartamerica.com) or follow her on Facebook by searching for her e-mail address: Dorislindsey@ymail.com.

J.R. (Jim) Nutting lives in Summerfield, Fla., but he is originally from Batavia, N.Y. As well as a retired miner and tattoo artist, he is a national award-winning, self-taught woodburning artist. For more of his work, search for Jim Nutting Painting With Fire on Facebook.

Adam Owen is a self-taught artist and amateur photographer living in Fairbanks, Alaska, with his wife and five sons. Adam grew up in Colorado and has always loved the outdoors, wildlife, and nature. To see more of his work, visit www.adam-owen.artistwebsites.com.

Michele Parsons is a woodcarver who fell in love with pyrography. She lives with her husband and dog in North Carolina. See more of her work online at www.parsonswoodartistry.com.

Over the years, **Deborah Pompano** has been an elementary school teacher, mall-based portrait artist, scrimshaw artist, piano teacher, and book cover and greeting card illustrator. Her book, *Woodburning Project and Pattern Treasury*, is available from Fox Chapel Publishing. See more of her work at www.harvestmoonstudio.net.

Sheila Rayyan lives on the island of Martha's Vineyard off the coast of Massachusetts. She and her husband both make their livings as artists. In addition to pyrography, Sheila does ceramics, drawing, sculpture, and dances with a local belly dance troupe. Someday she wishes to learn to play the bagpipes. See more of her work at www.motherspoon.com

Jo Schwartz picked up her first burning tool in 2005. After practicing daily for years, Jo feels that she is "getting the hang of it. I love everything about pyrography—the smell of wood, the smell of burning wood, and the different shades of sepia!" To see more of her work, visit Jo's website at www.joschwartz.net.

Danette Smith of Bellevue, Ohio, has been burning since 2003. Her motto is, "Keep burning and learning." Danette teaches classes and accepts commissions. See more of her work, including her tabletop easel, at www.dangeespyrography.com, or contact her at dangee1@frontier.com.

Robert Stadtlander lives in Mantua, Ohio, and spent most of his life as a quality engineer. He discovered woodcarving and woodburning in 1989 and since then has won numerous awards and exhibits widely in the Northeast and Midwest. Robert is available to teach woodcarving seminars and offers woodcarving tools and wood blanks. Contact him at 330-931-7847 or www.stadtlandercarvings.com.

Chris Wallace moved to Dodgeville, Wis., from California with her husband in the late 1990s to work for Walnut Hollow, and that is when she learned how to woodburn. Says Chris, "I would never call myself an expert, but it sure is fun to try new and different ways to woodburn." See Walnut Hollow products and find project ideas at www.walnuthollow.com.

Sue Walters is a self-taught, internationally renowned, and award-winning pyrographic artist. For pyrography tips and patterns, and a gallery of Sue's artwork, visit her website at www.suewalters.com.

Susan Zanella lives in northeast Maryland, where she has owned a print brokering business since 1995. Susan began working with gourds and pyrography in 2005. She enjoys the variety of artistic expressions a gourd allows. Susan sells her work at local fairs and teaches at gourd gatherings along the East Coast. Visit her website at www.gourdmarket.com.

TABLE OF CONTENTS

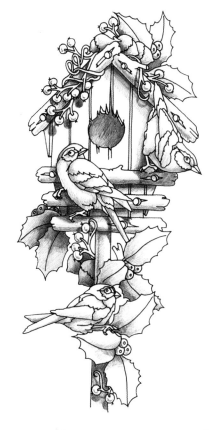

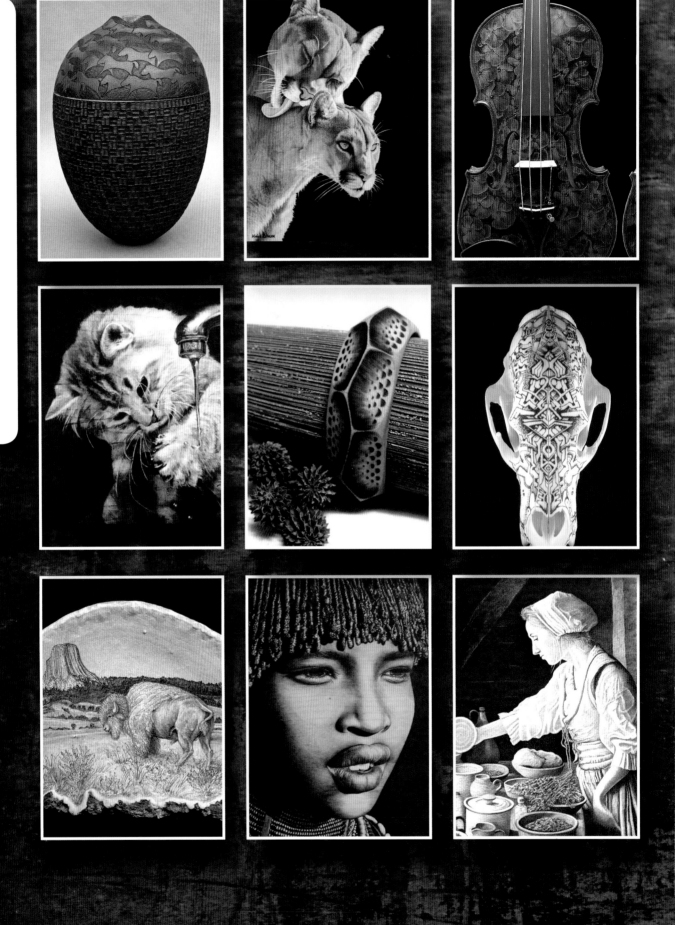

Sweet Success is 13" by 19" and burned on Baltic birch plywood. Chip Jones says, "This cowboy had already achieved success just by being in the mountains and getting to experience this beautiful view first-hand. Bagging his elk just made his trip all the sweeter."

"Observing pointing dogs in the field is a thrill for me," says Julie Bender, who took the photo that became *Special Delivery*, a 12" by 20" work on maple.

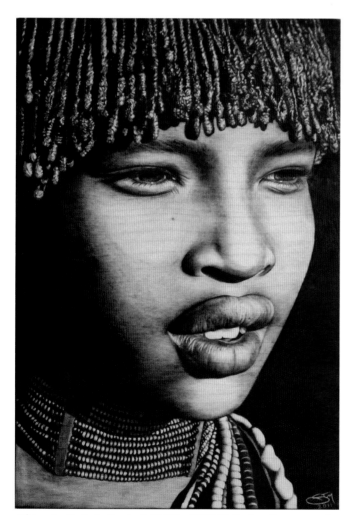

Africa, by Stefania Mante, is 7¾" by 11¾". Stefania calls pyrography the "perfect symbiosis between drawing and matter. Owing to the simple use of heat, a drawing emerges from matter and remains set in wood grains with an interplay of natural and warm colors. It is an indelible and timeless art."

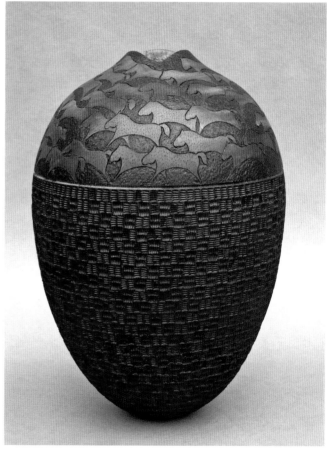

Mustang Series, 6½" by 4½", which Molly Winton made from koa, features extensive pyrography and branding.

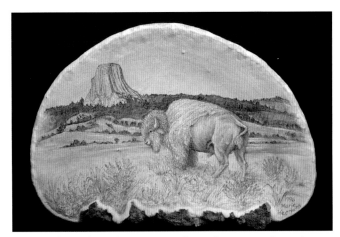

The Buffalo of Devil's Tower was burned onto an artist conk mushroom by naturalist and fungi artist Marie Heerkens.

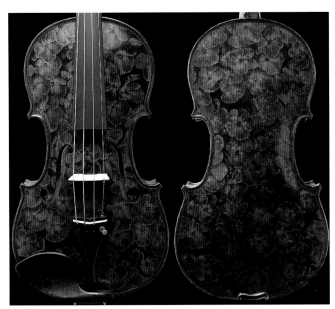

Dino Muradian, a completely self-taught pyrographer, has done custom pyrography on a variety of musical instruments, including this Glinga violin.

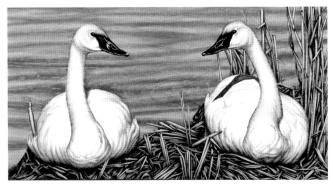

Trumpeter Swans, 17" by 34", was burned on ponderosa pine and tinted with watercolor by Mick Richards.

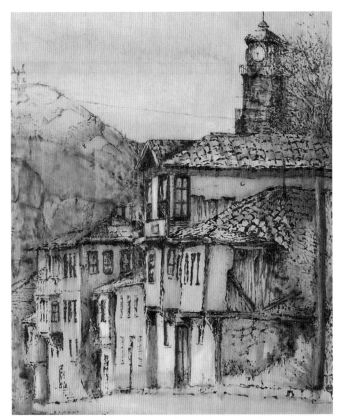

Esin Kesici Kabaş combines watercolors and pyrography on wood to create unique works of art like *Clocktower*. This piece measures 11" by 15".

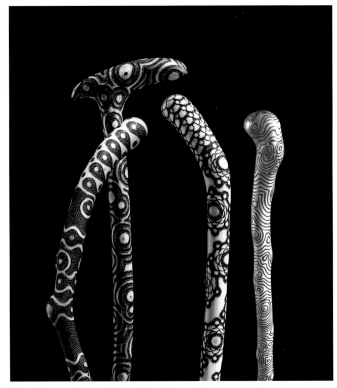

Peter Drewett's woodburned walking sticks measure between 2½' and 3' in length. The collection won third place at the 2012 20th Century Pyrographers exhibit at The Andrews Art Museum.

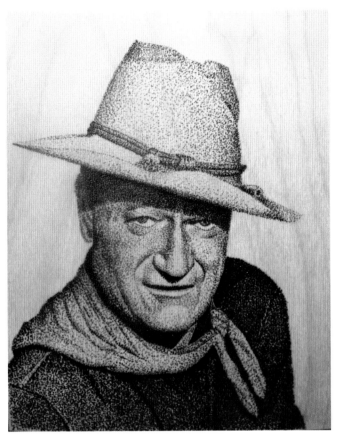

John Wayne is one of pyrographer Alex Yawor's recurring subjects. Alex burned this recent portrait using pointillism, or dots. He noted that there are no straight lines in the work.

Australian artist Scott Marr is fascinated by caterpillars and butterflies. *Vision* is 11" by 11¾" and made from pyrography, ochres, liquid chlorophyll, coreopsis flower wash, eucalypt bark wash, and plane tree charcoal.

Jenn Avery burned *Selkie Swim*, a mythological ocean scene, on a gourd. According to legend, the selkies of northern Scotland and Ireland can shed their skin and take on human form. "I portrayed the selkies in their seal form, and a few are looking up out of the water, possibly looking for the loved ones left ashore," Jenn says.

Cindy Adams burned this gorgeous iris on 140 lb. cold-press watercolor paper, and then added color with watercolors, watercolor pencils, and felt-tip pens.

Platter, 14", was burned by Tricia Newell. It is made of sycamore and shows multiple complementary floral images.

Red-Tailed Hawk, 12" by 16", was burned onto the surface of palmyra leaves by Vietnamese artist Tang Lo of Exotic Arts, who uses leaves to avoid harming trees.

Antlers is approximately 15" by 45" and was burned on pine wood and stained by Melanie Steinway of Melanie Steinway Illustrations.

Cate McCauley burned the award-winning piece, *Colonial Kitchen*, on watercolor paper. It measures 7" by 10".

Black Bear Skull took much longer and much higher temperatures than normal to burn, according to artist Peter Deligdisch.

Native American Portrait, 11" by 14", was burned on paper art board by Roger W. Bishop of Heirloom Portraits.

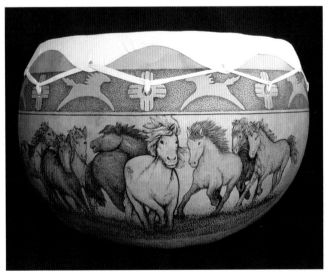

Nevada Wild Horses measures 10" by 18" by 18", was cut from a calabaza gourd, and was burned with both solid tips and wire nibs by Tia L. Flores of Pyrographic Calabaza Sculptures.

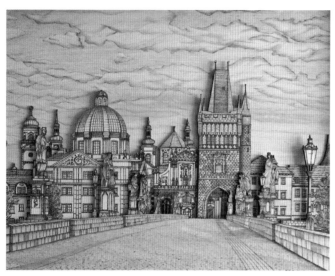

Self-taught Bulgarian artist Ivaylo Hristov burned this scene of the historic Charles Bridge that crosses the Vltava River in Prague, Czech Republic. Ivaylo burns individual pieces of wood, and then overlays them to create 3-D pyrography. Measuring 30½" by 23", this 3-D piece comprises 17 separate pieces.

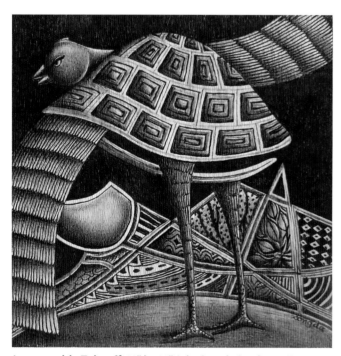

Inescapable Takeoff, 11" by 11", is by Songda Ouedrago. He says this piece "speaks to the hope for Africa's future—that things will be better someday and the tortoise will fly like a bird."

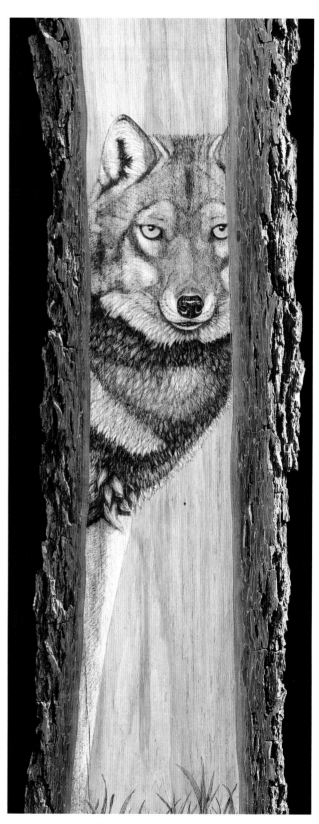

Thinking Like a Mountain She-Wolf, by Kathleen Marie, measures 14" by 46½" and is made of pecan. She says, "I love working with wood; it's a true partnership and the best medium for me."

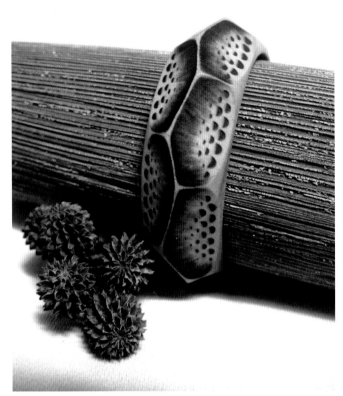

Biobangle by Kalina Gospodinova features an original contemporary faceted design. Made out of Acacia wood, it is burned with nature-inspired organic elements reminiscent of tribal motifs.

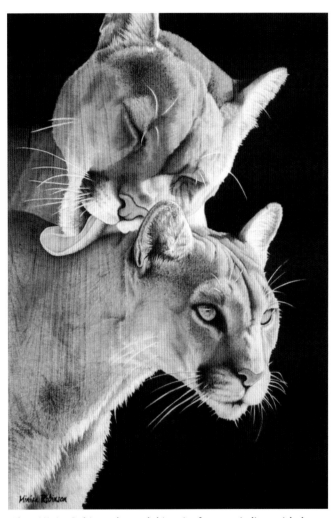

When Minisa Robinson burned this pair of mountain lions, titled *Affection*, she thought they turned out well, but the portrait still felt unfinished. She decided to try burning a solid black background—and now the lions seem to jump out of the wood!

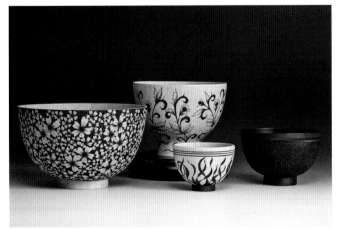

This group of Asian bowls is made from Bradford pear and decorated with pyroengraving and India ink. Michael Gibson turned the bowls, and wife, Cynthia Gibson, embellished the bowls with pyrography.

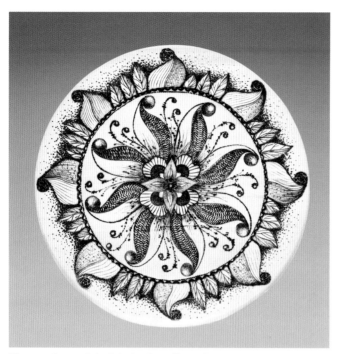

Harvest is an original design by self-taught pyrographer Aneliya Kochneva of Annie's Art Book. It was burned into a 9" round pine plate using a multi-setting woodburner that allows for subtle shading.

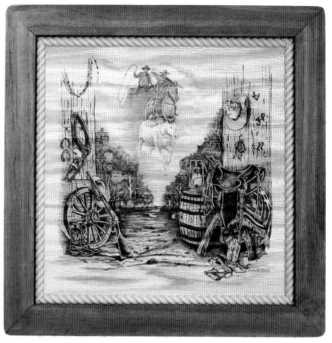

Ghost Riders by Danette Smith of Dangee's Pyrography was inspired by the Stan Jones song "(Ghost) Riders in the Sky." The 14" by 14" piece is accented with an oak frame and rope-like wood inlay.

Dining Table by Cecilia Galluccio is a 30" by 78" by 40" store-bought table that was hand-sanded and decorated using woodburning tools.

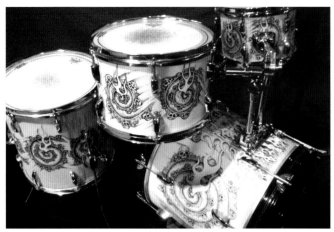

Drumset is the personal instrument of New York musician and pyrographer David Brickford of Dream Art Guitars. The original design was drawn on the raw drum shell and then burned.

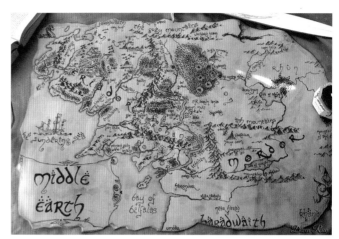

Middle Earth is a map depicting the universe of J.R.R. Tolkien's *The Lord of the Rings*. Designed by Portland, Or., artist Deven Rue, it was burned on untreated leather and conditioned for the final aged look.

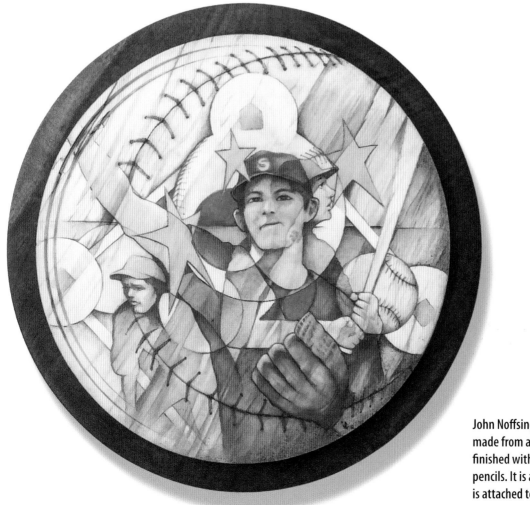

John Noffsinger's *Pitcher* was made from a piece of spalted maple and finished with guitar dyes and colored pencils. It is approximately 20" across and is attached to a walnut backing.

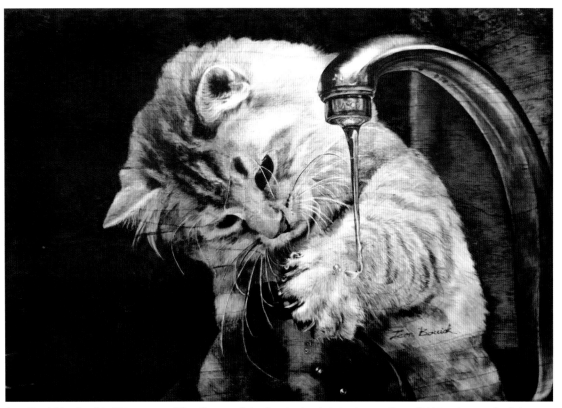

Jean Bouick's adorable kitten exemplifies the use of shading to simulate texture—the soft kitten has gradual changes between tonal values, and the faucet has defined edges where tonal values change.

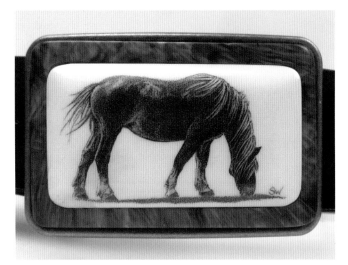

Sue Walters created this belt buckle from cow leg bone. She chose to burn this realistic horse to show how much detail can be achieved on bone.

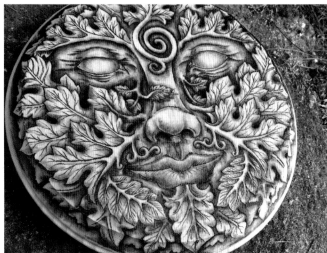

Sepia Greenman depicts one of the artist Michelle Greenwood's favorite motifs. This piece was penciled directly onto a pine wood box and then handburned for nearly 12 hours.

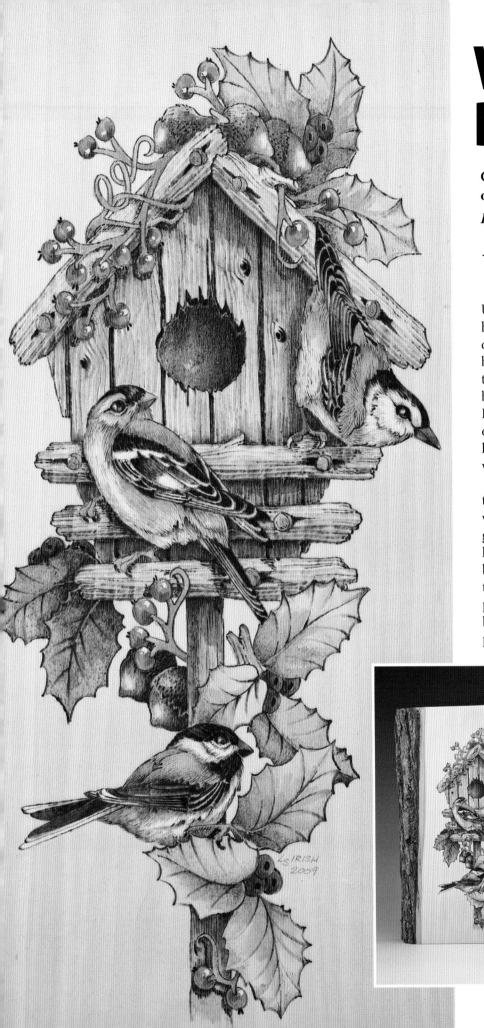

Winter Birdhouse

Create this impressive scene using only three woodburning nibs

By Lora S. Irish

Use just three woodburning tips and a handful of simple strokes to create this cheery winter scene featuring three birds. The trick is to work slowly—one tone, pattern, or area at a time—and build your burning in successive layers. In addition, I suggest practicing some elements of the design, such as the holly leaves, birds, and knotholes, on scrap wood before burning on the project.

This scene is lovely in the rich sepia tones produced with a woodburner. Use watercolors to add vibrant colors and give the project a completely different look. I chose a bark-edged slab of basswood to create a natural frame for the project. It's especially important to practice on scrap wood if you haven't burned on basswood before. I create a practice board to work out tones and textures before applying them to the project.

Remember to use a fan to draw smoke away from you while you work. Clean your nibs often as you burn, take your time, and have fun!

BIRDHOUSE: ESTABLISHING THE DESIGN

1 **Prepare the wood.** Sand the surface until it is very smooth, and then wipe it clean. If necessary, resize your pattern to fit your wood, and then transfer the simple line pattern to your blank using graphite paper. Because this pattern has vertical lines, use a T-square to ensure the pattern lines are aligned vertically on your board. Refer to the shading guide and layer guide as you complete the burning.

2 **Shade the background leaves and acorns.** Set your burning machine to a low temperature, such as 5.5. Using a standard writing tip and a random doodle stroke, fill in the background leaves and acorns on the top right and lower left of the birdhouse. Do a light layer of burning over the entire elements. Do a second layer over one-third of the leaves, and then a third layer over just the tops. This creates the shadowing.

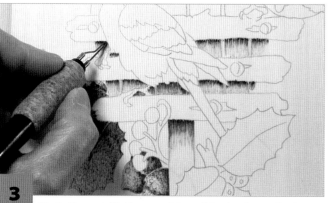

3 **Shade the post.** Working up and down, following the wood grain, use a tight scrubby or tight random doodle stroke to fill in the shadow on the post that supports the birdhouse. Use a simple straight line stroke to fill in the two areas on the house that fall behind the perch struts. Repeat the layers of burning twice, making each layer progressively smaller. The house has straight walls, so those shadows should have straight lines. The pole is rounded, so its shadow is curved.

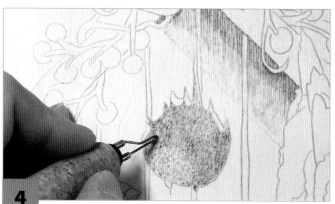

4 **Shade the house.** Draw a light pencil guideline about ¾" (19mm) down from the right side of the roof to indicate the shadow. Burn the shadow in long straight lines. Using a tightly packed random doodle, fill in the hole. Repeat the layers of burning under the eaves and in the hole twice, burning about half of the area on the second layer and about a quarter of the area for the third layer. The bottom edge of the hole shadow is almost circular to match the hole's shape.

BIRDHOUSE: CREATING TONAL VALUES

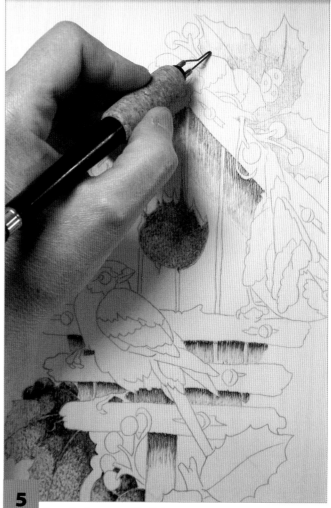

5 **Burn the foreground holly leaves.** Turn your burner down to a lower temperature (4.5 to 5). Use the standard writing tip and a random scrubby stroke to shade the remaining holly leaves. Concentrate your shading on the underside of the leaves, leaving them unburned where the light would hit. Curve the edges of the shadows. Deepen the shadows by burning a second layer on each leaf, covering about half of the previously burned area.

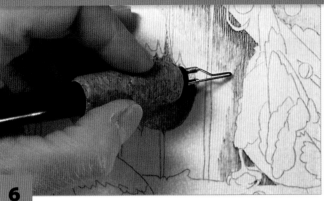

6 **Extend the house shading.** Using a long straight stroke, shadow behind the bird perched at the right of the house (a nuthatch). The shadow is deeper where the bird's shadow overlaps that of the roof strut. Also use the straight strokes to continue the shading on the post, filling in to create the highlight near the center.

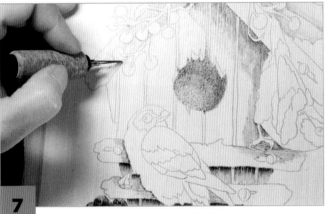

7 **Continue the shadows.** Using a straight stroke, shade the house and perch under the center bird (a goldfinch). Shade the house with vertical strokes and the perch with horizontal strokes. Shade the eaves under the berry vines using diagonal lines to match the roof struts.

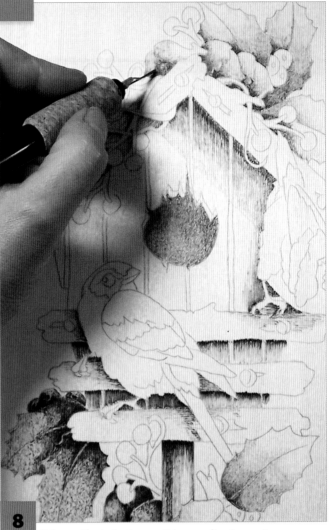

8 **Enhance the darkest areas.** Using a medium temperature setting (5), match the previous strokes, and slowly reburn the deepest shadows of each area. This includes the holly leaves, the left side of the post, the dark spots below the birds' feet, the eaves, the center hole, the area below the perch, and the acorns. You should now have four tonal values on each burned pattern area.

BIRDHOUSE: ADDING THE BERRIES

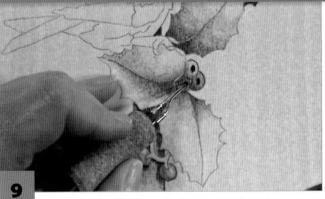

9 **Burn the berries.** Use the standard writing tip and a medium temperature (5) to burn the berries in large circular strokes. Darken a line along the upper right of each berry, but also leave an unburned highlight in the upper right of each berry. Darken the center of the holly berries.

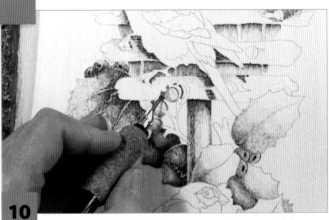

10 **Work the free-floating shadows.** Turn your burner up slightly (5.5) and use a small random doodle to create shadows under elements that are above, but not touching, other elements, such as the vines and berries on the roof. The berries are assumed to be close to the light source, so they have dark crisp-edged shadows.

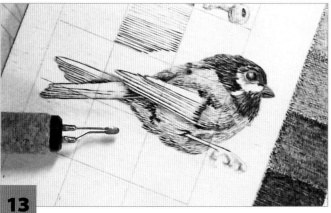

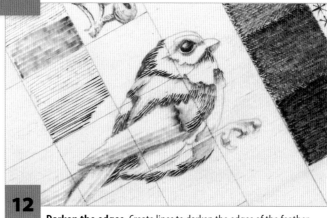

11 Start the birds. I recommend working through a few birds on a practice board before burning the birds on the project. You will follow the same steps for each bird. Change to a small round shader and lower your temperature (4.5 to 5). Burn long slow lines along the bottom, bottom right, or far right side of each area of the bird.

12 Darken the edges. Create lines to darken the edges of the feather groups. Overlap the strokes slightly to avoid unburned areas between them. Pull straight lines on the tail and wings, and curve the strokes to conform to the shape of the belly and shoulders.

13 Add the feathers. Turn the shader on its edge to add the dark areas of shadow. When the dark shadows are complete, turn down the burner slightly (4.5) and fill in the remaining feathers with a medium tone using a touch-and-lift stroke.

TIPS

CREATE REFERENCE MATERIAL

Cut a leaf shape out of a piece of paper and fold the leaf along the center vein. Bend the paper leaf to represent a natural leaf and use it as a reference to create realistic shadows in your project.

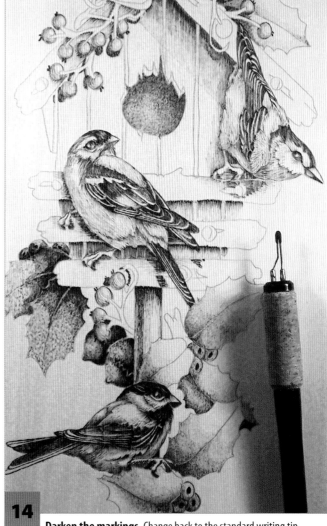

14 Darken the markings. Change back to the standard writing tip and turn the temperature up (7). Your pen should burn hot and dark, but not so hot it halos and not absolutely black. Use a random doodle to darken each bird's markings. Refer to the shading guide and photos for placement of the dark marks.

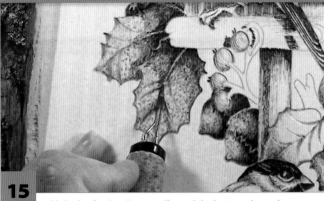

15 **Add the leaf veins.** Use a small round shader tip and a medium temperature (5 to 5.5) to burn the veins with little comma strokes. Work from the tips of the leaves toward the center vein or from the center vein out. Add extra shading along the tips on the low side to make them curl slightly. Don't burn the veins completely as they don't stretch from the edge all the way to the center.

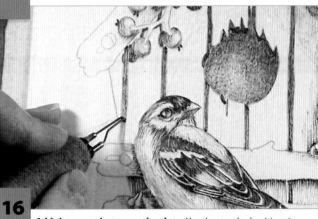

16 **Add the space between the slats.** Use the standard writing tip, a higher temperature (7), and a doodle stroke to burn the open areas between the wood slats to a dark tone. Burn the visible edges of the slats around the hole in the center of the birdhouse. These edges are burned to a very dark tone.

17 **Make a few knotholes.** Go back to the practice board. Using a small shading tip, place the tip on the wood for a few seconds to make a dark oval. Around that oval, slowly pull a dark half-circle comma stroke. Add several more larger comma strokes, moving the pen slightly faster for each so the burns are paler. Return to the project and create a few knotholes on the birdhouse.

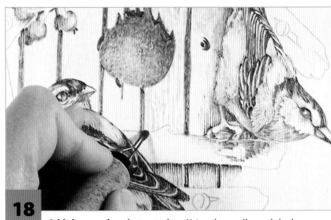

18 **Add the wood grain texturing.** Using the small round shader, lower the heat to medium (5). Use a long line stroke to work the wood grain: vertical strokes on the face of the house and horizontal lines for the perches. Be sure to curve the long wood grain lines around the knotholes.

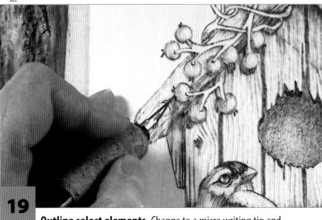

19 **Outline select elements.** Change to a micro writing tip and turn up the heat (7 to 8). Do not outline every element. The goal is to accent edges that are not well defined or don't stand out against their backgrounds. Accent the edge of the post, the edges of the perches, and the edges of the berry vines. Use the same tip to add a little shading to the berry vines.

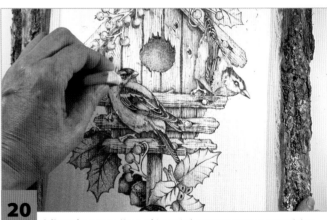

20 **Adjust the tones.** Use a white artist's eraser to erase any remaining pencil marks, then set your burning across the room and consider it carefully. Make any necessary adjustments. For example, to make the nuthatch and goldfinch come forward more, darken the shadows on the wall and perch to add separation. If you prefer, stop here, sign and date your work, and seal it with several thin coats of acrylic. Do not seal your work if you plan to color it.

BIRDHOUSE: COLORING THE BIRDS

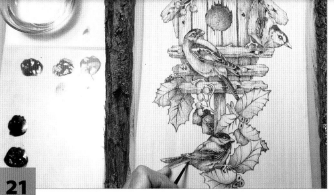

21 **Add the yellow.** Place cadmium light yellow, cadmium medium red, raw sienna, cobalt blue, and Payne's gray on your mixing tile and thin with water. Paint the breast, undersides, and lower tail area of all three birds yellow. Mix yellow and red to create bright orange and work it over these same areas. Allow some yellow to show. Paint the goldfinch's (center bird's) head yellow. Blend the chickadee's (bottom bird's) tail from yellow to soft brown by adding a light coat of raw sienna.

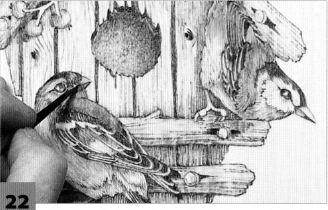

22 **Add color to the back and wings.** Mix Payne's gray and cobalt blue to create a Wedgewood gray. Use it to paint the tail, wings, and back of the nuthatch (top bird). Mix raw sienna with the orange from step 21 and paint the backs of the goldfinch and chickadee. Add a touch of the orange mixture around the goldfinch's eye, throat, and cheek to shade his face. Paint the goldfinch's beak orange, adding a second coat to the bottom beak to darken it.

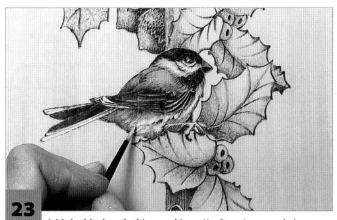

23 **Add the black and white markings.** Use Payne's gray to darken the black markings on the birds' tails, backs, and wings. Apply Payne's gray to the legs and feet of the nuthatch as well. Use several very thin coats of Chinese white on the white areas of the birds' faces, wings, and bellies. Use the orange mixture for the goldfinch's legs and feet.

BIRDHOUSE: COLORING THE LEAVES

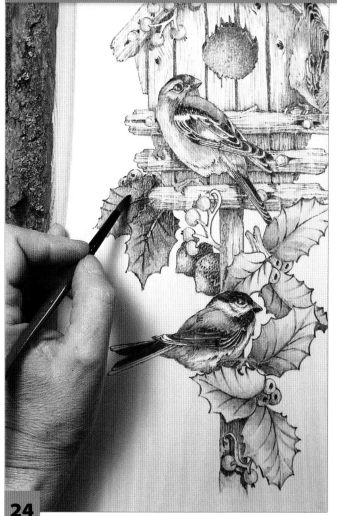

24 **Work the holly leaves.** Add pale green and evergreen to your mixing tile. Mix pale green and cadmium light yellow to a soft green and paint the holly leaves in the foreground. Add a small amount of orange to the green mix and paint the mid-ground leaves. Use evergreen to shade the foreground and mid-ground leaves, and to flood the background leaves. Paint a second coat of evergreen on the background leaves to add shading.

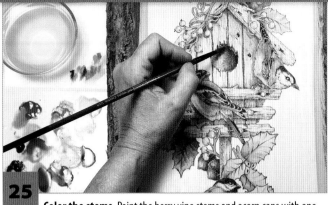

25 **Color the stems.** Paint the berry vine stems and acorn caps with one coat of raw sienna. Add a small amount of burnt sienna to the raw sienna and shade the vines where they are tucked under another element. Use the sienna mix for the acorn bodies. Add a touch more burnt sienna to the mix and shade the sides of the acorns, the acorn caps, and the darkest burned areas of the birdhouse hole.

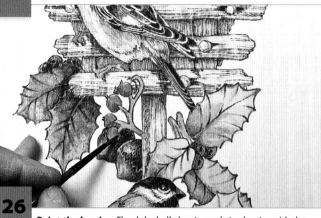

26 **Paint the berries.** Flood the holly berries and vine berries with the original orange mixture. Shade the holly berries with a touch of cadmium medium red. Use the red to shade the vine berries where they touch the vines.

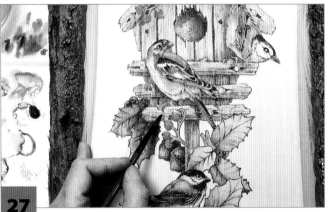

27 **Shade the birdhouse.** By now, you should have a pan of very dirty, mud-colored water where you have been cleaning your brush. Use this to paint the inside section of the birdhouse and its post. Because old wood is seldom brown, the water will add an aged look to the house no matter what color it has become. Use raw sienna to randomly brush small strips of color on the inside section of the house as well as the horizontal support sticks. Do not paint over all of the muddy water.

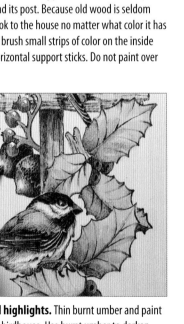

28 **Add the final shadows and highlights.** Thin burnt umber and paint over the darkly burned areas of the birdhouse. Use burnt umber to darken the inside of the birdhouse hole. Use Chinese white to add small highlight dots to the vine berries and acorn bodies.

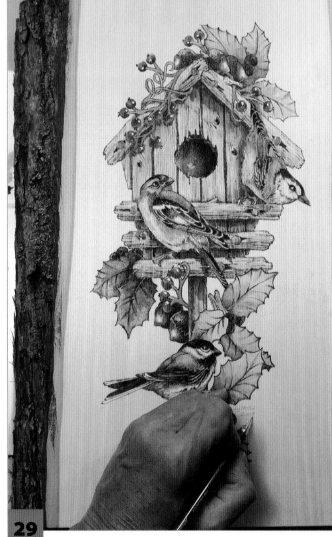

29 **Finish the project.** Sign and date your work, and then let the project dry overnight. Use two to three light coats of acrylic spray to seal the piece.

Birdhouse pattern

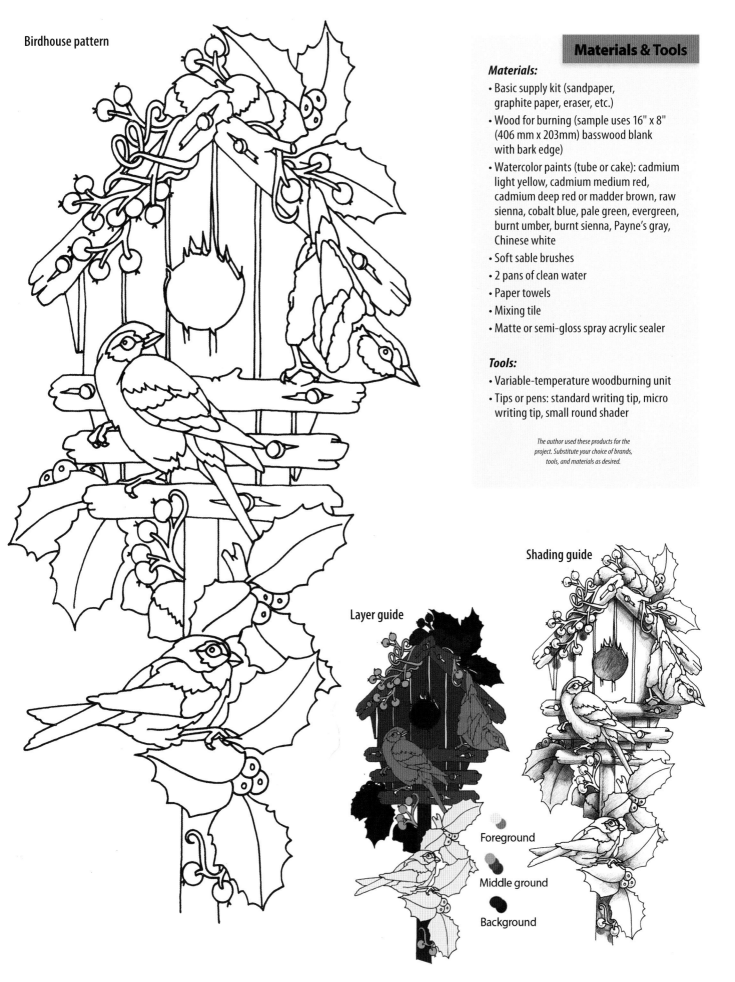

Materials & Tools

Materials:
- Basic supply kit (sandpaper, graphite paper, eraser, etc.)
- Wood for burning (sample uses 16" x 8" (406 mm x 203mm) basswood blank with bark edge)
- Watercolor paints (tube or cake): cadmium light yellow, cadmium medium red, cadmium deep red or madder brown, raw sienna, cobalt blue, pale green, evergreen, burnt umber, burnt sienna, Payne's gray, Chinese white
- Soft sable brushes
- 2 pans of clean water
- Paper towels
- Mixing tile
- Matte or semi-gloss spray acrylic sealer

Tools:
- Variable-temperature woodburning unit
- Tips or pens: standard writing tip, micro writing tip, small round shader

The author used these products for the project. Substitute your choice of brands, tools, and materials as desired.

Shading guide

Layer guide

Foreground

Middle ground

Background

Celtic Border Plate

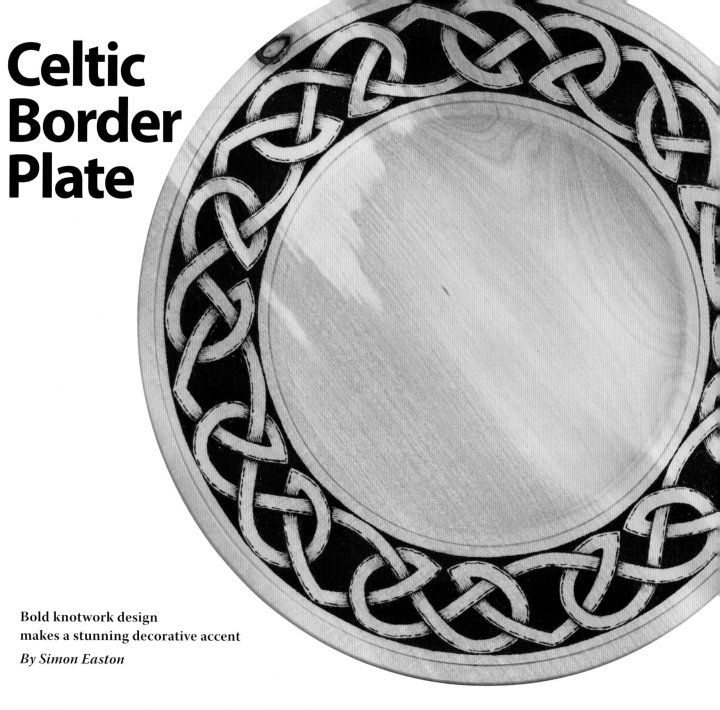

**Bold knotwork design
makes a stunning decorative accent**

By Simon Easton

Wooden plates and platters make ideal surfaces for pyrography. Plates can be found in a range of sizes and shapes. Some plates are completely flat surfaces, whereas others can be turned to feature shaped rims and edges. This project features a patterned border around the raised edge of a wooden plate.

The success of any Celtic-style design depends on the time and effort you put into drawing the rough design. Define the inside and outside border of the design by drawing two concentric circles about 1" to 1¼" apart. Adjust the pattern size to fit your plate, and then transfer the pattern to the plate. Take care to ensure all of the lines match up and the design flows smoothly and seamlessly.

Using the edge of a fine spoon shader, outline the bands, making sure the lines meet and cross precisely and the bands weave in and out correctly. Complete one section at a time, then go on to the next segment. When the knotwork bands are completed, outline the concentric circles.

Shade the outer and inner backgrounds touching the circles first, being careful to maintain your crisp outlines. Next, use the small shader to outline the inner edges of the design, and then use a medium shader to fill in the large areas within the pattern.

Switch back to the small shader to add shadows where the individual bands cross under each other. Shade a series of small lines that run away from the overlapping bands. Use a light flicking motion to make

Celtic border pattern

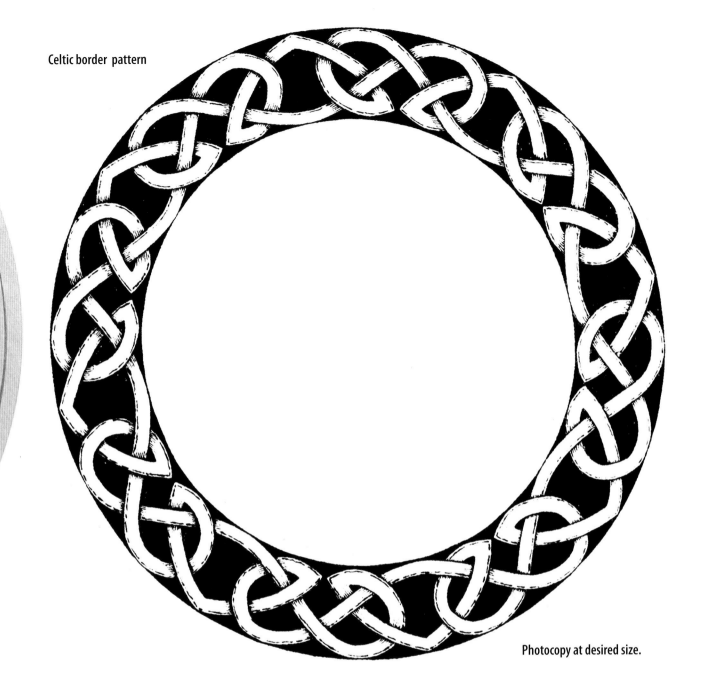

Photocopy at desired size.

lines that are darker near the overlap and fade away.

Finally, use a fine tip to run an irregular line around one edge of the band. It doesn't have to be smooth or solid because the line acts as subtle shading, giving the impression the bands are slightly three-dimensional.

Use the same technique—careful copying, working one segment at a time, and shading the line intersections—for any Celtic knotwork pattern.

Materials & Tools

Materials:
- Blank wooden plate, any size
- Pencil and eraser
- Tracing paper

Tools:
- Pyrography machine with tips: fine, small, and medium spoon shaders
- Ruler
- Compass

The author used these products for the project. Substitute your choice of brands, tools, and materials as desired.

Small Mill

Practice basic techniques with this
tranquil landscape

By Cheryl Dow

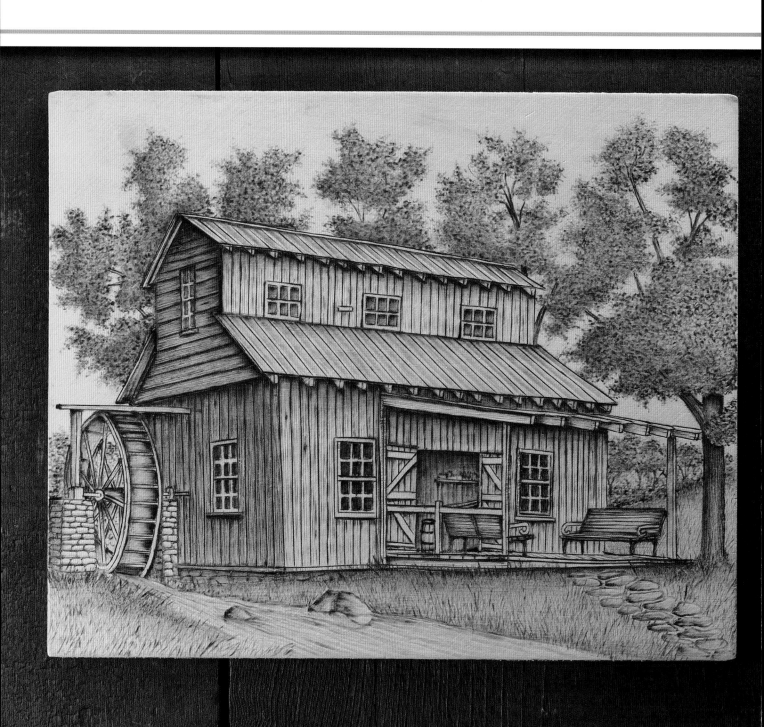

Small mill pattern

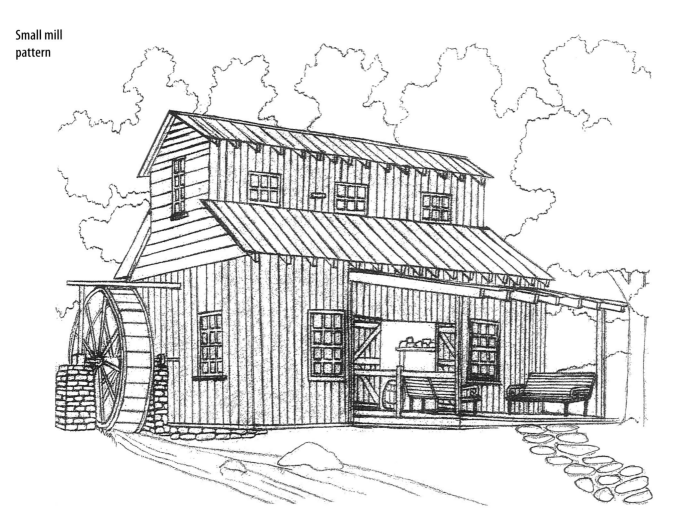

While this tranquil scene looks intricate in its details and perspective, it's actually easy to create and a good way to practice your basic techniques.

Using the skew, burn the board lines with strong dark strokes from top to bottom. Do the entire mill, including the doors, windows, seats, and interior. Still using the skew, add the grain lines with quicker lighter strokes from top to bottom. Burn long lines. Do not use smaller connecting lines because it will look like fur rather than wood grain. Touch in a small dot here and there, and run small lines through the wood grain to make a few knotholes.

Turn the shader on its side to shade under the edges of the building's side and under the porch. Pull the shadows down, shading the entire left side of the mill. Use the bottom of the point to put shadows under the eaves.

Using the skew, burn the tree branches. The branches get thinner the farther away they are from the trunk. Make the sides of the trees darker by using the side edge of the shader to add shadows along the sides and round out the trunks. Using the ball tip, add the leafy areas with a floating light touch in a scribbling motion.

Use the skew to add grass; use longer lines in the foreground and shorter lines in the background.

Use the ball tip to outline the stones in the wheel supports and the rocks in the stream and on the path. Use the shader on its side to softly and gently burn the water in the direction of the flow lines.

Materials & Tools

Materials:
• Your choice of material to burn

Tools:
• Tips: round-heel skew, bent spear-point shader, 1/16" (2mm) ball point

The author used these products for the project. Substitute your choice of brands, tools, and materials as desired.

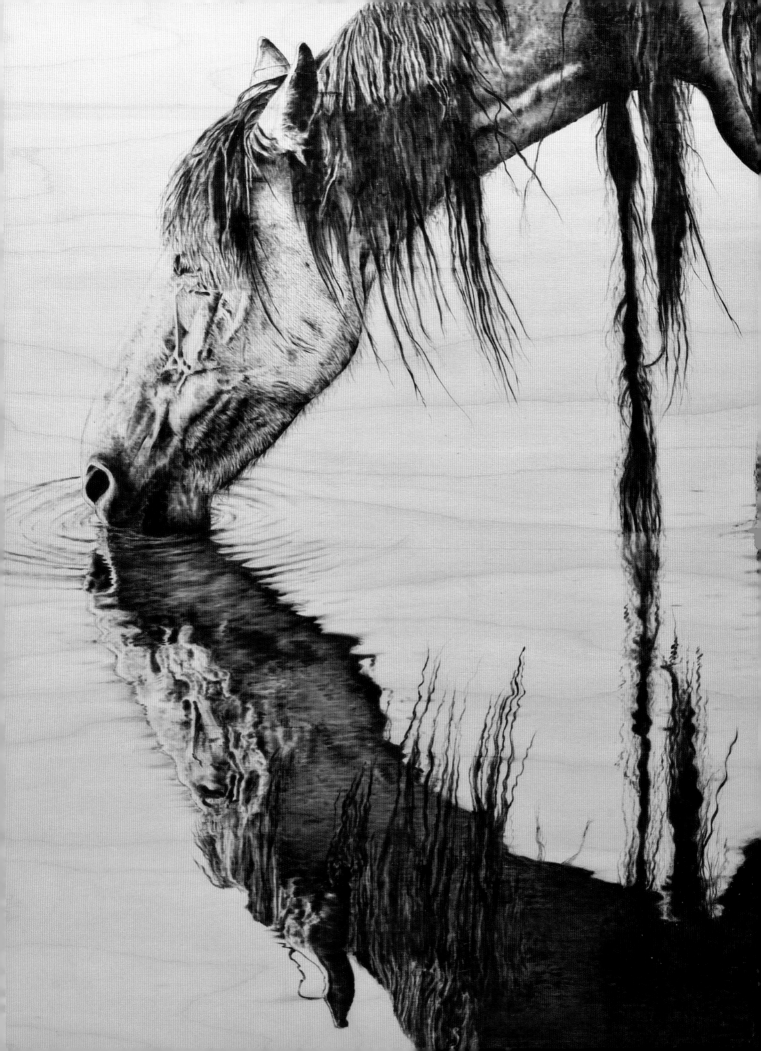

Somewhere West of Laramie

Clever use of wood grain simulates ripples in water
By Adam Owen

Inspiration is an essential component when creating artwork that stands above the rest. When I saw Ron McGinnis's photograph *Somewhere West of Laramie* I was immediately inspired and knew I had to burn it. The sepia tones of the photo and the tranquility of the scene juxtaposed against the wildness of this stallion really captured my attention. I contacted Ron seeking permission to use his image and he generously agreed.

Getting Started

I burned this design on maple ply because the grain of the wood helps enhance the impression of the surface ripples on the water. I attempt to use the grain of the wood as a component of the overall design. I like to select my wood from a local wood mill to ensure the highest quality possible.

I decided to go big on this piece because I felt that a larger burn was necessary to generate the impact this image deserved. After printing the image on a D-size plotter printer, I taped it to the wood and transferred it using graphite transfer paper. When I transfer an image onto wood, I transfer the outline, eyes, ears, nose, and other features that are important to capture the essence of the image, such as skin folds and fur grain transition areas. Pay special attention to facial features, especially the eyes. In the end it won't matter how well the overall burn turned out if the eyes are not burned accurately, dimensionally proportionate, and realistic.

Burning the Design

I use a Detail Master Sabre IV woodburner. Despite owning numerous tips for it, I primarily use only one: the pointed shading tip. I use the edge for fine detail strokes and the base for shading. I sometimes use a razor-edged tip for the fine hair detail that is commonly required for wildlife work.

For this burn I start at the nose and work my way up the head, neck, brisket, and legs, constantly referencing the printed photo. I know some pyrography artists burn dark areas in layers, increasing the temperature of the burning tool with each layer to get a smooth, dark burn. However, I typically increase the temperature of the tip and burn it in one pass. After completing the body of the horse, I move on to the reflection, again working from the nose toward the body.

It is essential that you constantly refer to the original image to ensure the image is realistically and accurately portrayed on the wood. I also look at the burn from a distance, looking for details that the eye misses when you're close. Improvements to the burn often jump out at me when I'm standing across the room. Finally, once I think I'm done, I put the burn away for a few days. After a week or so I get it out and usually see areas that need additional work.

Finishing the Project

I finish most burnings with several layers of water-based satin polyurethane. However, for commissioned work I try to avoid applying polyurethane in case the buyer wants changes. Once I have applied the polyurethane, it is extremely difficult to make changes.

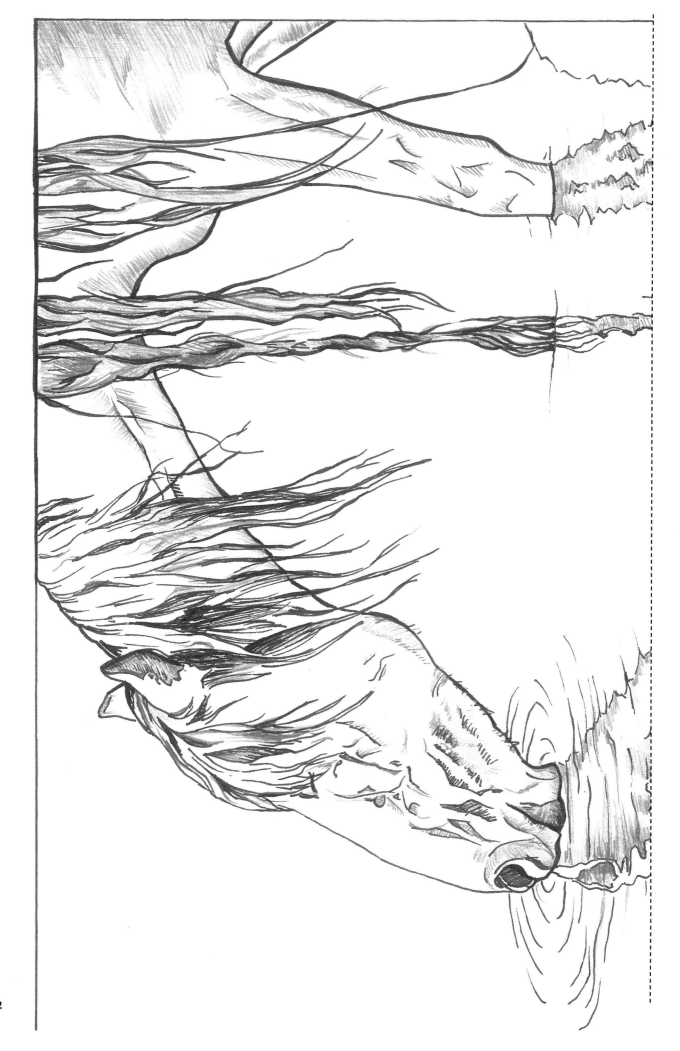

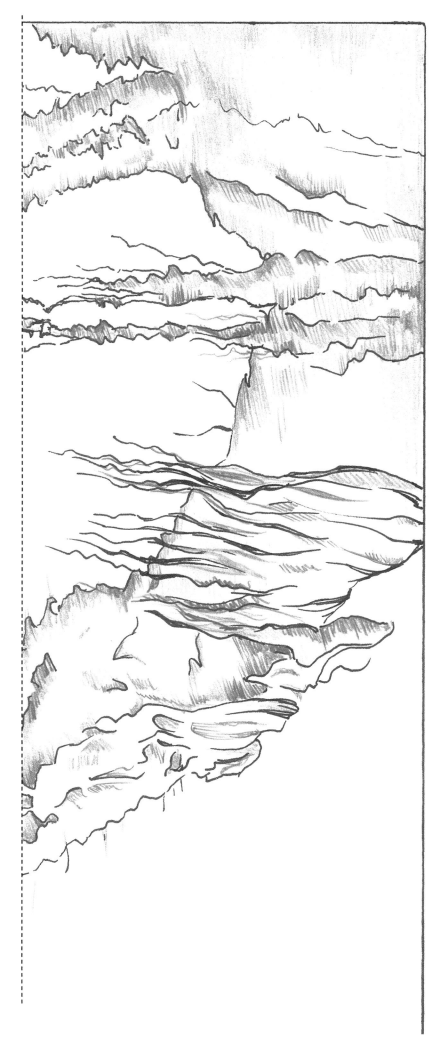

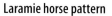
Laramie horse pattern

Projects 33

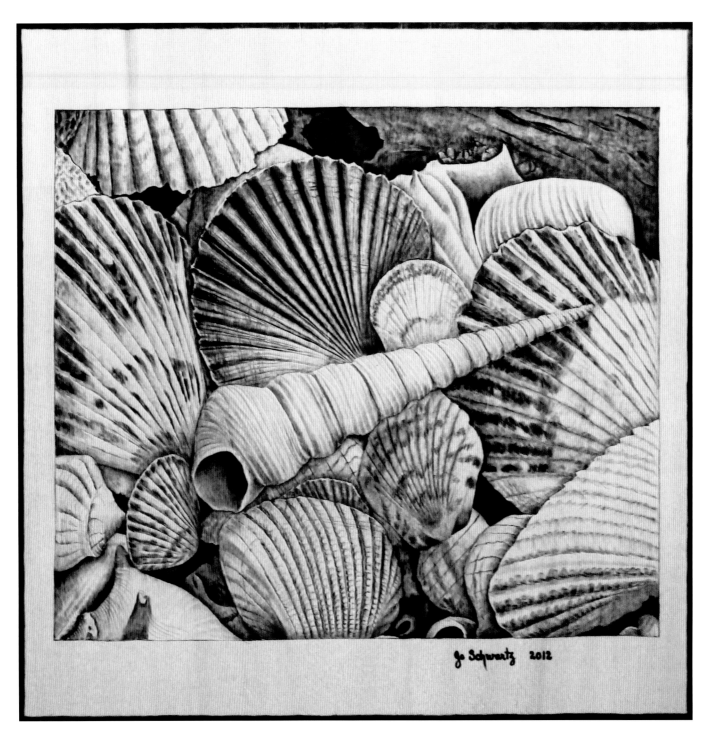

Soothing Sea Shells

Use shading, not lines, to show the texture of these shells

By Jo Schwartz

Seashells are one of the most iconic souvenirs from a beach. Everyone has seen them, and most people who have visited a beach come back with one or two. With their combination of smooth material and radiating or spiral texture, shells make great subjects for pyrography.

Sea shell pattern

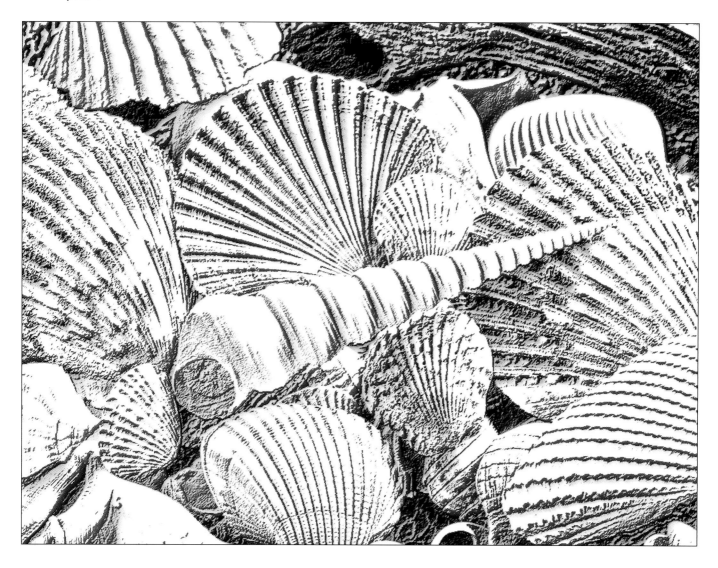

Burning the Pattern

Start by transferring the pattern to the wood (see page 106 for methods).

When burning the image, I lightly erase the traced lines of a small work area before burning it so I can make sure there are no straight edges to the shells. I use a very low heat setting and begin with the center auger shell, burning around it to create the 3-D effect of it sitting on top of the other shells.

On the larger shells, I burn under the edges first, which means I shade the shells beneath before returning to the tops to complete the detailing. Once you find the darkest or deepest areas in the pattern, you can burn dark and deep to set the base color. Then, reduce the heat in the different layers of shells until the heat is lightest for the top shells. I sign my name with a ³⁄₆₄" (1.5mm)-diameter ball stylus.

Materials & Tools

MATERIALS:
- Maple, 1" (25mm) thick:
 12" x 12" (305mm x 305mm)
- Basic pyro kit (see page 101)

TOOLS:
- Variable-temperature woodburner with tips:
 medium spear shader, small spear shader,
 ³⁄₆₄" (1.5mm)-diameter ball stylus

The author used these products for the project. Substitute your choice of brands, tools, and materials as desired.

Creating a Reflection

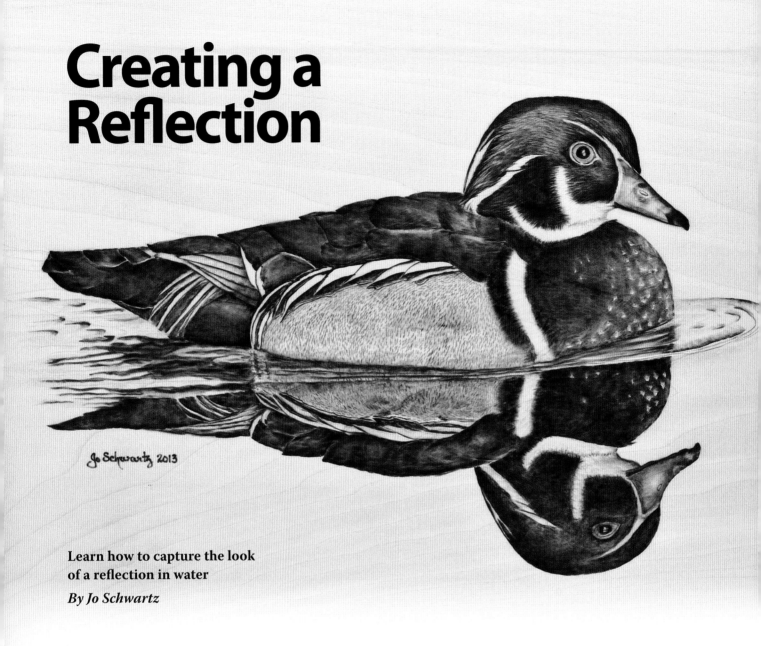

**Learn how to capture the look
of a reflection in water**

By Jo Schwartz

When I saw Al Freeman's original reflected duck photo, I thought the composition was striking, and I was immediately inspired to recreate the image as a woodburning. I contacted the Sandusky, Ohio, photographer for permission and got to work. I call my version *Morning Swim*.

What makes this project more challenging than a normal burn is the reflection of the duck in the water. Water bends light slightly, which means the reflection isn't an exact duplicate of the upright image—it needs to look a little softer. A successful reflection creates a striking look in any portrait.

As you burn this or any reflection, make it a habit to burn the real duck first. That way, if you make a mistake on an area, you can match the reflection to the mistake. Your piece will end up looking great because it will be balanced.

TIP

MAKING A BURN REFERENCE

I often use photo software to turn a copy of a color reference photo into a sepia-tone photograph. This helps me see the different depths of shading needed. I keep a full-size copy of the photo beside me as I work and an enlarged copy of the photo on my PC monitor. Rotate the photos as you rotate the wood while you burn.

Getting Started

Add to the overall look of the piece by choosing wood with grain that resembles ripples in water. You'll be burning upside down at times, so mark the top of the wood project piece. Then, use graphite paper and transfer the pattern (see page 106) as follows. A. Start with the real duck. I trace minimal details and rely on the photograph for details when burning. B. Trace the water line. Then, turn the wood upside down and trace the reflection duck. C. With the blank still upside down, find the matching parts of the real duck and reflection duck. Focus on marking the chest line and the white portions, which will help you keep your bearings as you burn. The water will fill in as you burn from one duck to the other.

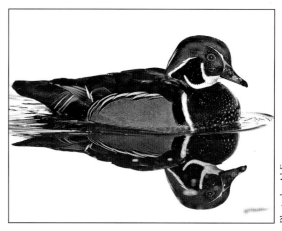

Photo by Al Freeman

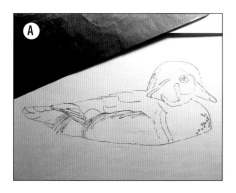

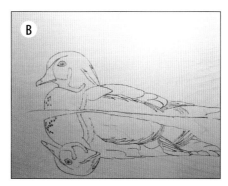

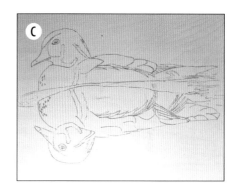

REFLECTION: BURNING THE DUCKS

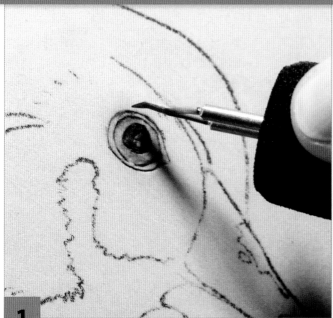

1 **Burn the eyes.** Use the edge of a small spear shader and a medium-low heat setting; my burner was set at 4. Burn the real eye. Then, burn the reflected eye. Notice that details in the reflection are not as sharp because the reflection is in murky water. Erase the graphite lines as you work.

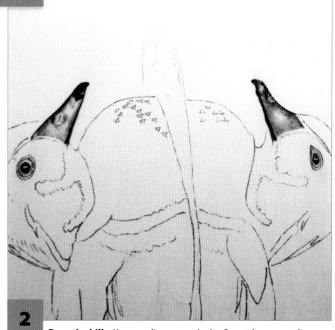

2 **Burn the bills.** Use a medium spear shader. Do not burn an outline; make the edges of the bill with a touch-and-lift motion to prevent hard lines. Burn the real duck's bill and then the reflection. The reflection should be darker than the real duck, so either turn the burner temperature up slightly, or burn both ducks to the same depth of color and then lightly re-burn the reflection using the medium spear shader held flat; this will smooth the details, making them murky, and deepen the shadow.

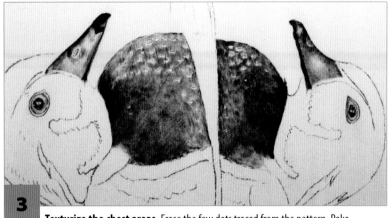

3 **Texturize the chest areas.** Erase the few dots traced from the pattern. Poke the corner of a single-edge razor blade into the wood at an angle three times to form a triangle, and then use the tip to pluck out the tiny triangle of wood. Use the photo as a guide as you carve a few rows of triangles. Sand the plucked areas with 320-grit sandpaper, and then burn the chest areas. The carved areas will usually stay unburned, but you may need to go back and recarve a few areas that were accidentally darkened.

4 **Burn the tail feathers and the large feathers along the back of the heads.** Use the medium spear shader and increase the heat until you get a dark, but not scorched, burn. Test and practice the technique on scrap. Touch the burner down at the left edge and pull/shade toward the right. Avoid burning the white feathers.

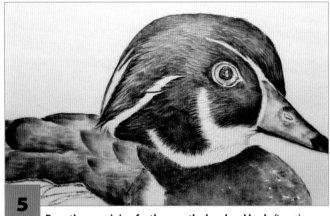

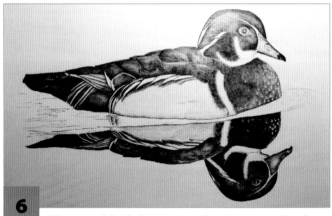

5 **Burn the remaining feathers on the head and back.** Burn the feathers smoothly first, and then go back and add lines or texture details. Use light pressure when burning; soft wood depresses easily when you apply heat. For the white areas, such as the real head, chest, and neck area, turn the burner down to very low heat (setting 1 or 2) and use the edge of the shader to pull the texture through. This technique gives subtle shading to the white areas on the throat.

6 **Fill in most of the dark areas.** Leave the wings, water, and ripples for last. Use the techniques explained earlier. Then, shade the wings. Shade the real wing lightly and the reflection wing a bit darker using the flat of the medium spear shader. This technique burnishes the surface of the wood.

REFLECTION: ADDING TEXTURES AND RIPPLES

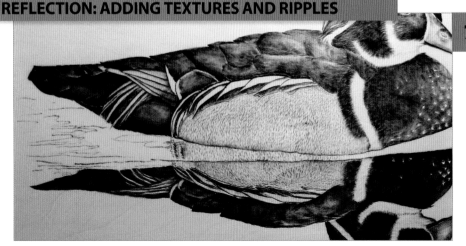

7 **Add the wing texture.** You can draw each of the tiny wing patterns visible in the photo, but I only hint at the details. Use the edge or side of the tip of the small spear shader at a medium heat setting to burn short lines. Follow the flow or direction of lines in the pattern. Begin in the upper right corner of the wing along the white feathers and work down the right side. Then, fill the middle area. Continue the texture into the water. Turn the blank and keep your hand at the same angle. Work down into the reflection wing. Work slowly and keep a steady rhythm.

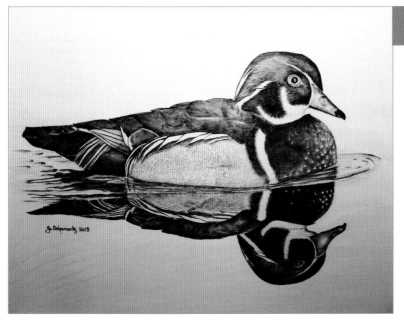

8 **Create the water ripples.** Use the touch-and-lift technique and the medium spear shader for all of the edges. Use four or five shade variations for the water. Start with a low heat, and burn the rounded areas of water in front of the duck. Pay attention to the area where the chest reflects on the water—finish the long shaded ripple before blending the real chest with the reflection chest. Then, use one long stroke to pull all the shading from the front, through the middle, and to the tail area. Don't push too hard. It only takes three pulls to get the water effect. Burn the lighter oval next to the body under the wing tip. Darken the area around the oval. Use the medium shader to elongate the darkest ripples and make their color match the darkness of the bellies. Darken the water between the duck and reflection until you match the darkest shading on the ducks. Then, darken the light oval and shade any areas you missed. Reduce the heat and pull a few short strokes beside the really dark area under the tail. Look at the overall project and check to see if you need to shade anywhere to balance the ducks. Sign your name.

Reflection duck pattern

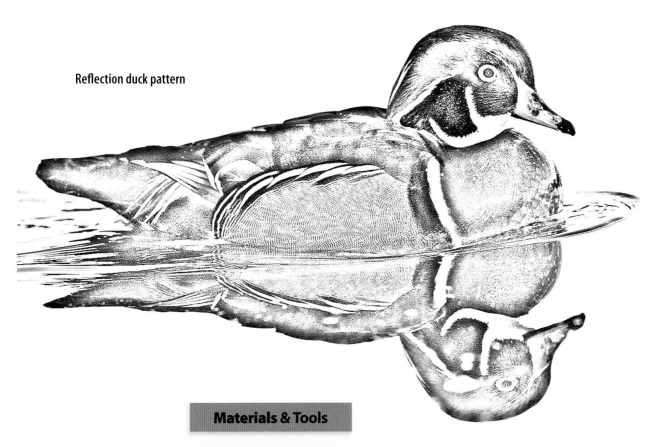

Materials & Tools

MATERIALS:
- Basswood, 1" (25mm) thick: 12" x 12" (305mm x 305mm)
- Sandpaper: 320 grit
- Basic pyro kit (see page 101)

TOOLS:
- Variable temperature wood burner with tips: medium spear shader, small spear shader
- Single-edge razor blade

The author used these products for the project. Substitute your choice of brands, tools, and materials as desired.

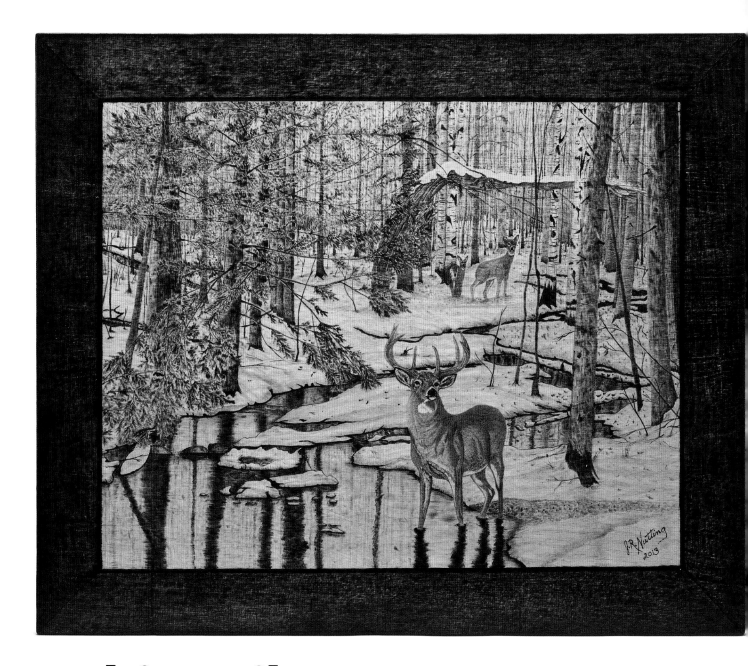

Whitetail Deer

Stunning detail captures the spirit of this forest resident

By J. R. Nutting

The inspiration for this burning came from the time I spend in the woods hunting and teaching my children about wildlife and nature. I like the outdoors and wildlife landscapes, so that is what I often burn.

Like most of my projects, I drew this design freehand onto the blank, using a few photos for reference. (You may wish to gather reference photos of your own to look at while you detail the deer.) This design, which measures 18" by 22" (457mm by 559mm), took me about 100 hours to complete. It's a slow process, so take your time and have fun just creating.

Getting Started

Start by cutting the blank to a size that suits you and enlarging the pattern to match. Sand the blank with 320-grit sandpaper—I use a vibrating palm sander—and then switch to 600-grit sandpaper. Hand-sand with the grain with 1500-grit sandpaper; this makes the surface of the wood feel like glass. Wipe off the dust with a cloth.

I drew the pattern right onto the blank, but you can also use graphite paper to trace the pattern (see page 106 for instructions). Center the design on the blank, leaving about 2" (51mm) around each edge so you can burn the frame later (see Step 12).

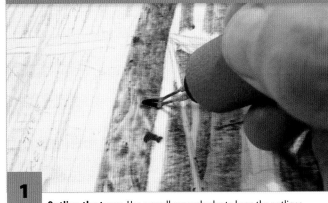

1 **Outline the trees.** Use a small spear shader to burn the outlines of the primary foreground trees. Then, position the tip so the flat side is against the wood and angle it slightly. Shade the texture of the pine trees. Switch to a small round shader to burn the dark details of the tree trunks and branches without leaves.

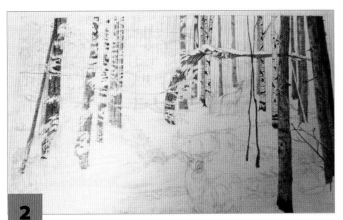

2 **Detail the birch trees.** Move on to the white birch trees. These trees have really dark spots where the bark has peeled off or where knots are visible. Burn these spots really dark, and burn the edges of the trunk lightly, but leave the rest of the trunk unburned so the trees look white.

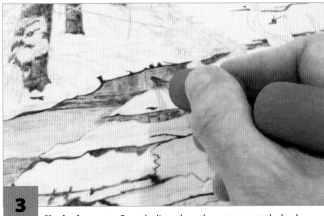

3 **Shade the water.** Burn the line where the water meets the bank dark to create the illusion of the water and the bottom of the bank. Shade the edges of the stream bank with the flat part of the tip. Use the side of the tip to lightly shade the water. Work from side to side and make sure you leave unburned highlights.

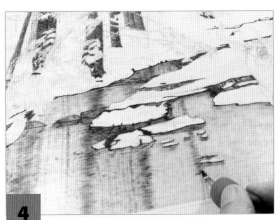

4 **Draw the reflected trees.** Use the flat thicker part of the tip and increase the heat setting on the burner. Use a side-to-side motion to burn the reflected trees and deer leg. Then, burn the stones and clumps of snow in the water.

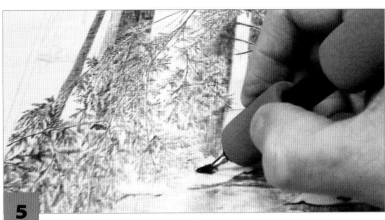

5 **Create the branches and pine needle clusters.** For the branches, use the flat part of the shader tip. Pull the tip toward you and tip the burner up slightly as the branch gets thinner. For the pine needles and clusters, make a short sweeping motion outward with the flat of the tip to form the clusters. Add a few single needles to the tip of the cluster using the side of the burner tip to give the illusion of lots of needles.

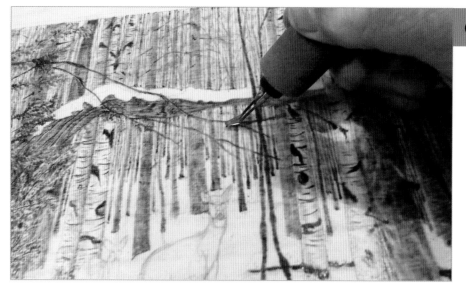

6 **Fill in the background trees.** Use the flat part of the shader tip to fill the background with smaller trees. Stagger the tree trunks so some are a little higher, which creates the illusion they are farther away. The farther away the trees, the lighter I shade them and the smaller I make them. On the bottom of the smallest and farthest trees, I use an upward sweeping motion to give the illusion of even more distance in the deepest parts of the woods.

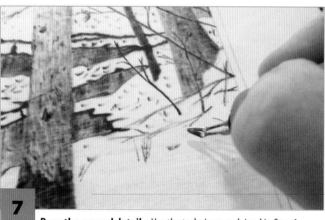

7 **Burn the ground details.** Use the technique explained in Step 1 to burn the yearling trees, but make the yearling trees smaller and darker. Make an upward sweeping motion with the side of the tip to create twigs, grass, and fallen branches. Use the flat of the tip and make a sideways sweeping motion to burn the fallen leaves.

8 **Shade the snow.** Start on the stream banks and make a slightly curved upward motion to show the banks. Shade the hills at a slight downward angle with the flat of the shader. Go back over the same spot several times to make it darker as needed. Use the same technique to add shadows around the bases of the trees in the snow.

DEER: BURNING THE DEER

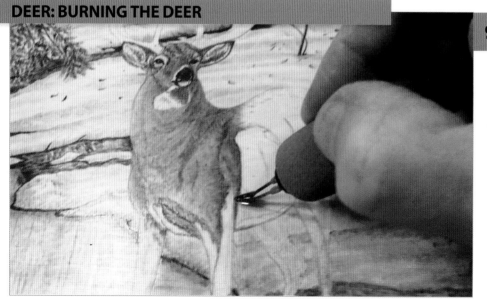

9 **Burn the buck's body.** Use the small round shader and burn the eyes, nose, and mouth. Shade them lightly, and then use the tip of the shader to darken them as needed. Leave the highlights unburned; use a razor blade to scratch out the highlights if you need to. Burn the ear fur, darkening as needed by burning over the area again. Then, shade the body fur, paying attention to the wrinkles and muscle groups, leaving the white areas unburned. Finally, go back and shade the white areas lightly.

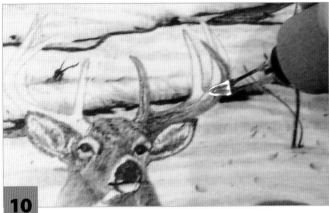

10 **Burn the antlers.** Use the tip of the burner to lightly outline the antlers. Then, burn any grooves or lines in the antlers, again burning lightly several times to darken necessary areas. Leave light areas for highlights.

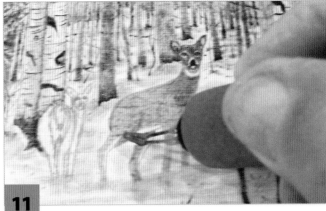

11 **Burn the background deer.** These deer do not require as much detail, so just shade them in layers from light to dark, paying attention to the muscle groups. Erase any visible pencil lines.

DEER: BURNING THE FRAME

12 **Mark the miters.** Instead of adding a commercial frame, I burn the edges of the plywood blank to resemble a frame. Mark the corner miters and burn a deep line along them with the edge of a large spear shader. Use the same shader to burn a ¼" (6mm)-wide dark outline 2" (51mm) from the edge. Then, use the same tip to shade the remaining 1¾" (44mm) of the frame. The frame should not be as dark as the outline.

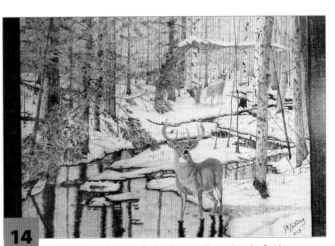

13 **Burn the edges of the frame.** Use a hand-held propane torch to burn the edges of the plywood to finish the frame. This eliminates the unsightly white edges. Set the completed project on an easel for a few days and note the areas to change. Make these changes before applying a finish.

14 **Apply the finish.** My wife, Carolyn, usually applies the finish because I'm too sloppy. Brush on a coat of clear semi-gloss Minwax polyurethane. Allow the finish to dry overnight and then sand lightly with 320-grit sandpaper. Wipe off the sanding dust and apply a second coat of polyurethane.

Whitetail
deer pattern

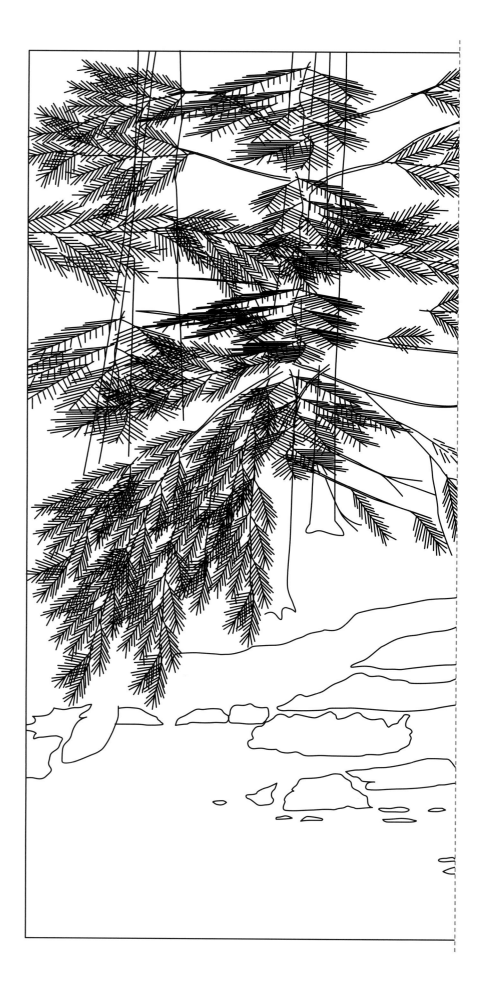

Materials & Tools

MATERIALS:
- Baltic birch plywood, ½" (13mm) thick: 18" x 22" (457mm x 559mm)
- Scrap plywood (to practice and test tips)
- Sandpaper: 320, 600, 1500 grits
- Polyurethane, such as Minwax: semi-gloss

TOOLS:
- Variable temperature wood burner with tips: small spear shader, large spear shader, small round shader
- Vibrating sander
- Cloth to remove sanding dust
- Paintbrush
- Handheld propane torch
- Basic pyro kit (see page 101)

The author used these products for the project. Substitute your choice of brands, tools, and materials as desired.

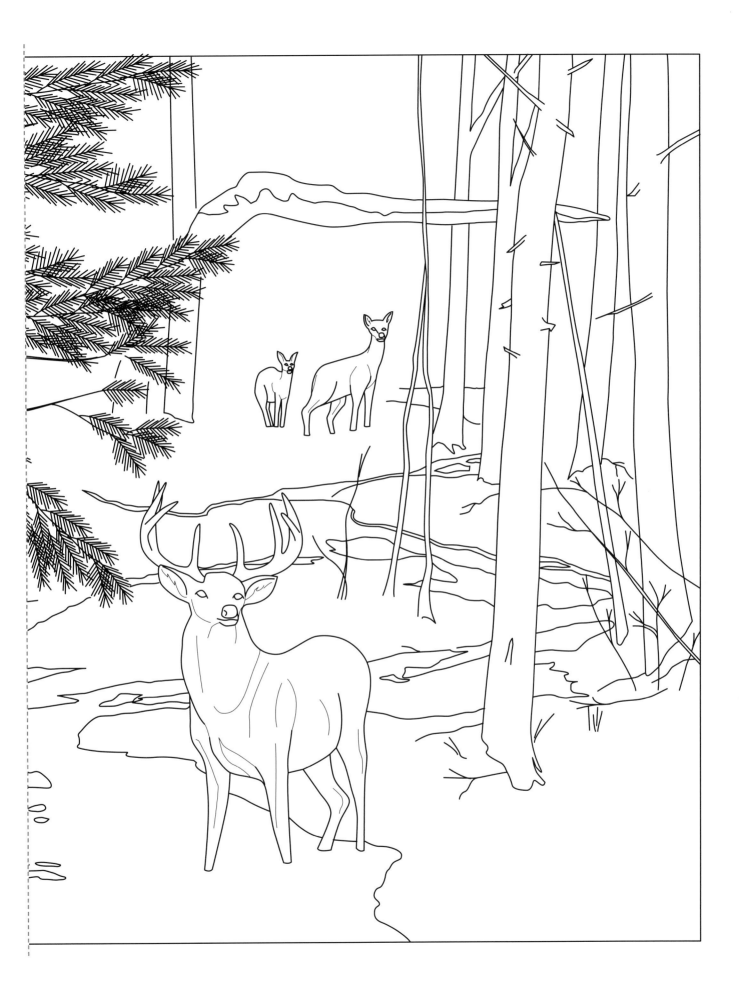

Woodburning Winter Scenes

Practice burning cold snowy scenes using warm sepia tones

By Robert Stadtlander

It can be difficult to create a winter scene using a woodburner. The sepia tones tend to give your work a warm feel, which is the opposite of what you are trying to accomplish. I achieved a wintery feel with these two pieces by using a shading tip to make the lines soft and amorphous rather than clearly defined.

Lighthouses make great landscape scenes in various media. I especially like this one for the dark and cold environment surrounding it. I had originally relief-carved this scene, but then a fellow woodcarver/woodburner inspired me to do a woodburned version. The pattern should provide many hours of burning fun for you during a long, cold winter.

I decided to burn the cabin in the woods after carving similar scenes in basswood eggs. I love the cabin and its wooded setting because of its mystery. I am still discovering things about it to this day. People have pointed out faces hidden in the trees, and if you look closely, there is an Indian chief with outstretched arms at the base of the mountains. These figures and faces were all unintentional—some were discovered years after I created this picture.

Burning the Scenes

Sand the blank with progressively finer grits of sandpaper up to 800 grit. Trace the sketched version of the pattern onto the board using a lead pencil, graphite paper, and masking tape. Use a non-slip pad to hold the piece in place while you work. Before approaching complex areas, practice on a piece of scrap wood. I printed the shaded version of the pattern on a transparent paper to help position objects correctly in the scene.

I used a medium spear shader for most of these projects, but switched to a pointed skew to burn the narrow lines. Use a razor blade to scratch out any mistakes. Erase any remaining pencil marks with an eraser. I do not apply finish to my pieces.

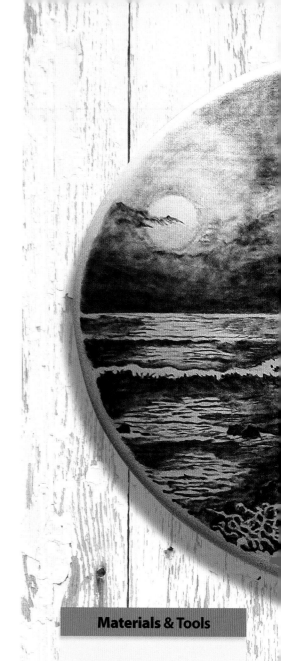

Materials & Tools

MATERIALS:
- Oval basswood plaque, 1" (25mm) thick: lighthouse scene 14" x 18" (356mm x 457mm)
- Basswood, 1" (25mm) thick: winter cabin scene, 11" x 14" (279mm x 356mm)
- Transparent paper

TOOLS:
- Variable-temperature woodburner with tips: medium spear shader, pointed skew
- Basic pyrography kit
- Non-slip pad (available at grocery stores)

The author used these products for the project. Substitute your choice of brands, tools, and materials as desired.

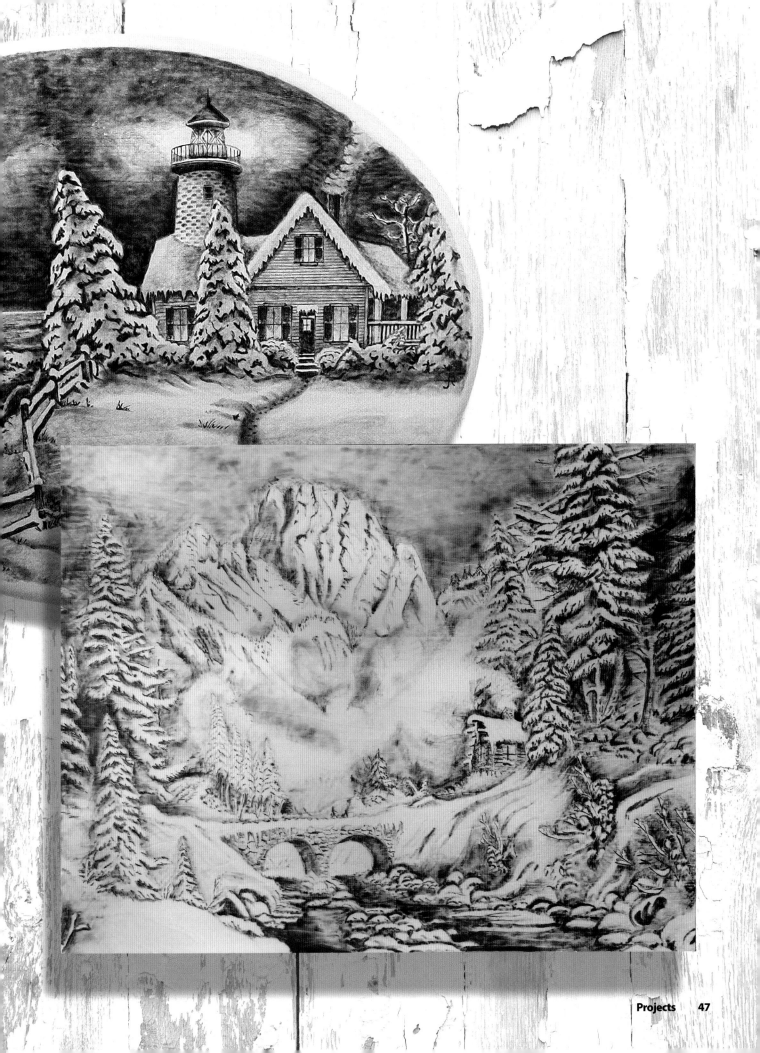

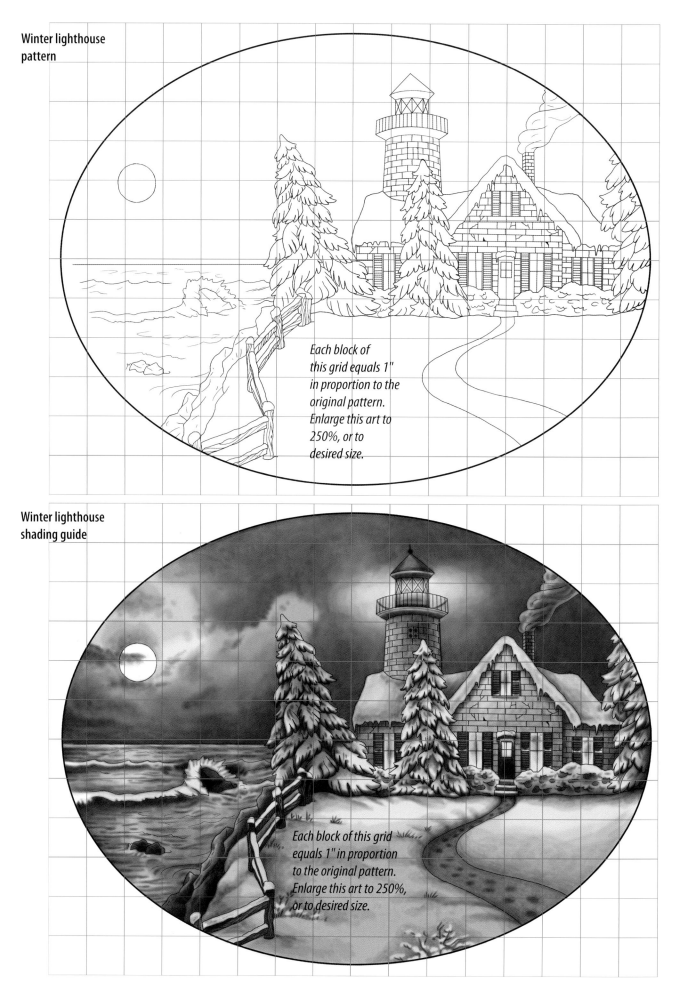

Winter lighthouse
pattern

Each block of
this grid equals 1"
in proportion to the
original pattern.
Enlarge this art to
250%, or to
desired size.

Winter lighthouse
shading guide

Each block of this grid
equals 1" in proportion
to the original pattern.
Enlarge this art to 250%,
or to desired size.

Winter cabin pattern

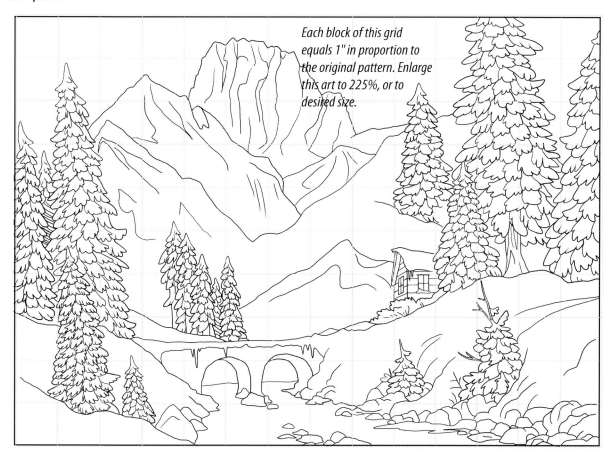

Each block of this grid equals 1" in proportion to the original pattern. Enlarge this art to 225%, or to desired size.

Winter cabin shading guide

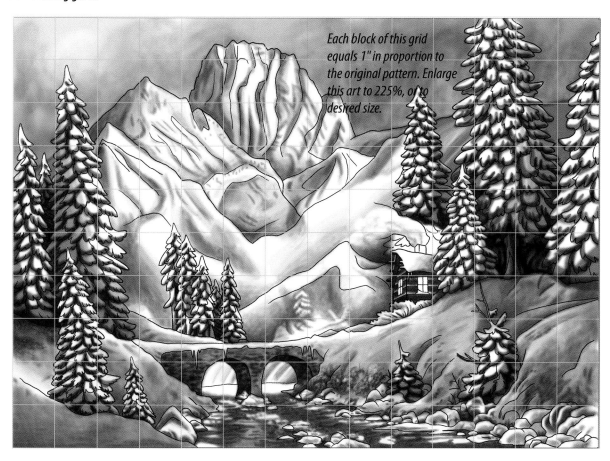

Each block of this grid equals 1" in proportion to the original pattern. Enlarge this art to 225%, or to desired size.

Cool Case for Mobile Devices

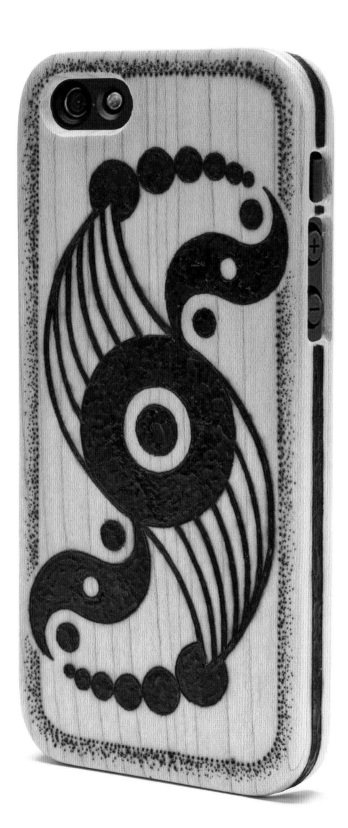

Customize your phone or tablet with a cover design inspired by crop circles

By Simon Easton

Last summer, my family was walking through the Neolithic stone circle at Avebury, in Wiltshire, England, when we saw an exciting sight from the brow of a hill—a large, ornate crop circle. These intriguing crop formations appear out of the blue, and there is endless debate about their origins. Are they manmade? Are they the result of visitors from another world? Is there a natural explanation for the phenomenon?

Regardless of their secrets, the bold geometric patterns are beautiful, so I incorporate them in my pyrography designs. For this project, the contrast of applying a beautifully tactile piece of wood to a shiny, slightly anonymous technological device of glass and plastic sums up my creative ethos completely, particularly when combined with imagery based on the inexplicable mythology of the crop circle.

Getting Started

Search the Internet for wooden cover blanks for your device. Many suppliers make solid wooden cases for mobile phones or computers. Choose one made of pale wood, which will create a better contrast with the woodburning. Look for an unfinished case; if you must choose a finished one, sand it with fine-grit sandpaper before burning it. Be careful not to purchase a "wood effect" case; this term often describes an image of a wooden texture or a simulated wooden surface made from another material, such as plastic, rather than a solid wooden cover.

Measure your wooden blank and enlarge or reduce the pattern to the correct size. You may wish to consider using only part of the design in a corner or along an edge, or reducing the size and placing the pattern in a corner—the options are endless.

Use tracing paper and a pencil or graphite paper to transfer the design to the back of the blank (see page 106 for additional methods).

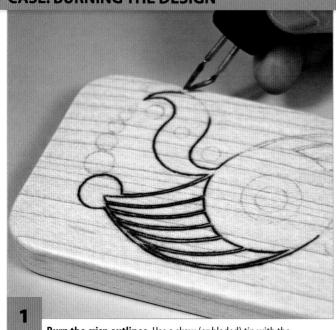

1 **Burn the crisp outlines.** Use a skew (or bladed) tip with the burner set at a medium-high temperature. Burn around the outline of the crop circle pattern. Keep the lines smooth and fluid for a clean design.

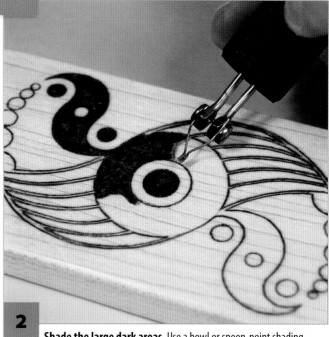

2 **Shade the large dark areas.** Use a bowl or spoon-point shading tip with the same temperature setting. Shade the darker areas. Keep the shading within the outlines to keep from ruining the form of the pattern. You can shade two ways: keep the tone as even as possible, or add a textured or graduated shade. I keep the tone as even as possible.

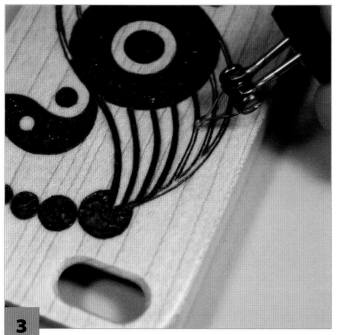

3 **Shade the tight dark areas.** Use the edge or the lip of the spoon-point tip to shade the areas where two lines meet at an acute angle or where the outlines are close together. The bowl of the tip might be too large to shade neatly between the lines without crossing over them.

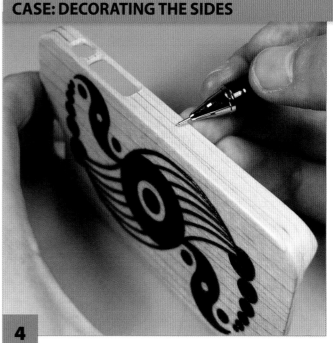

4 **Draw a pattern on the sides of the blank.** Draw two parallel pencil lines around the edge of the blank; I use the tip of my finger as a running guide. This border can be thin, thick, shaped, or irregular. Consider using a border made up of small repeated shapes, such as circles or dashes.

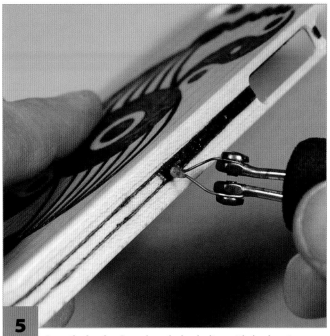

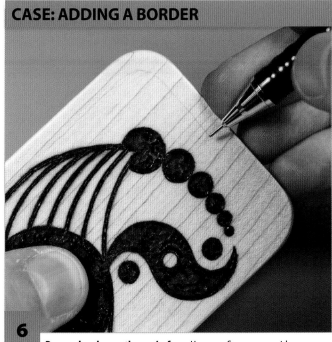

5 **Burn the border.** Burn along the border lines with the skew tip. Make sure the lines are just right, and be careful that you don't burn your fingers in this narrow area. Switch to a bowl or spoon-point tip and shade the inside of the border (like you did in Steps 2 and 3). Work slowly and steadily to make sure you don't slip as you burn.

6 **Draw a border on the main face.** Use your finger as a guide for the pencil as you draw a border around the main design. The border frames the pattern and creates an element of visual depth, so stop drawing where the line meets the design so it appears that the border goes under the main image.

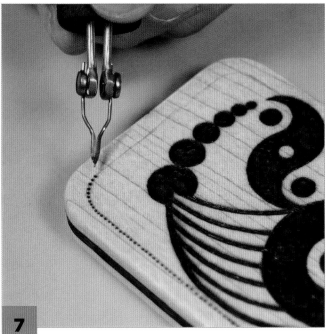

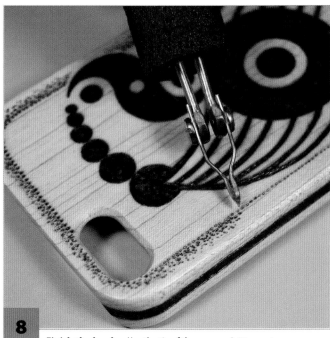

7 **Begin burning the border.** Use the tip of the spear point to create a dotted border along the pencil line. To enhance the feeling of depth, stop where the line approaches the crop circle pattern.

8 **Finish the border.** Use the tip of the spear point to create an area of stippled shading around the outside of the dotted border. Use fewer or lighter dots to graduate the shading so it appears to get lighter as it approaches the edges.

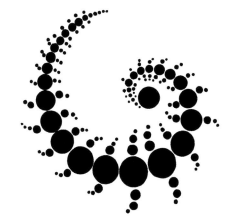

Mobile device case patterns

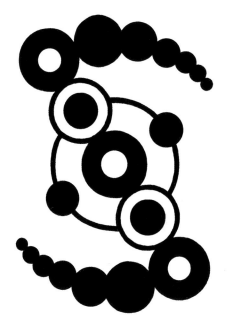

Materials & Tools

MATERIALS:

- Blank wooden mobile device cover/case

TOOLS:

- Ruler

- Basic pyro kit (see page 101)

- Circle stencils/ template (optional)

- Pyrography machine and tips: skew (blade), spear, spoon, or shading point

The author used these products for the project. Substitute your choice of brands, tools, and materials as desired.

Finishing the Project

To finish the project, spray it with matte or glossy varnish, or apply microcrystalline wax (available from art supply stores). You can also leave the wood unfinished; the pyrography is fairly durable.

Decorative Light Switch Cover

Add a decorative touch in an unexpected place

By Sheila Rayyan

Light switch covers, or switch plates, are a great way to add a fun accent piece to a room or hallway. One at a time, I've been replacing all of the plain plastic switch plates in my house with my own woodburned ones. Visitors have a great time going on a "treasure hunt" to find all of the unique switch plates I've made.

Lately I've been fascinated by the beautiful etched scrollwork found on firearms and antique armor. I used the scrollwork designs as my inspiration for this switch plate and added dragonflies, because I think dragonflies are cool.

Making the Light Switch Cover

I prefer to work on unfinished wood switch plates; you can usually find them in assorted switch configurations at a hardware store. We've also included a pattern for you to make your own.

To make a wooden plate, drill and countersink the screw holes, and drill the blade-entry hole for the switch hole. Cut the switch hole with a coping saw or scroll saw. Carve a shallow recess in the back to accommodate the switch and box. Add a metal switch cover, if desired. Cut the blank to size and round or chamfer the edges. Sand the plate with 220-grit sandpaper, and then remove the sanding dust with a tack cloth. Transfer the pyrography pattern to the blank.

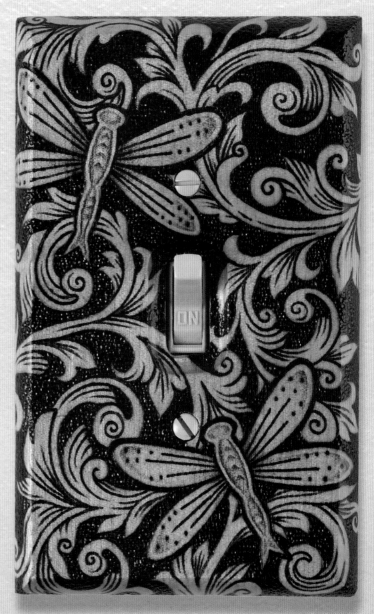

I like to outline the main pyrography design with a 1.5mm ball stylus. Add the detail lines with a .8mm ball stylus. Fill the dark background with a medium spear shader. Then, use a 3mm ball stylus to stipple, or dot, the background for more texture. Use a spear shader to shade the dragonflies. Finish the plate with a few coats of varnish to protect it from hand oils and dirt (and grubby little fingers).

Light switch cover
burning pattern

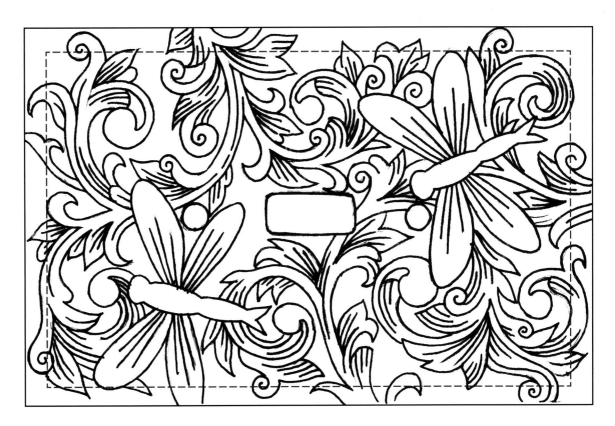

Light switch cover &
recess pattern

Materials & Tools

MATERIALS:
- Unfinished wooden light switch cover OR pine, basswood, or maple, ⅜" (10mm) thick: 3 ½"x 5 ⅝" (89mm x 143mm)
- Narrow metal switch plate cover (optional)
- Varnish

TOOLS:
- Drill with bits: ⅛" (3mm)-dia., countersink bits
- Scroll saw or coping saw
- Router with bits: straight (rear recess), roundover or chamfer bits
- Basic pyrography kit

- Woodburner with tips: spear shader, 0.8mm ball stylus, 1.5mm ball stylus, 3mm ball stylus

The author used these products for the project. Substitute your choice of brands, tools, and materials as desired.

Personalized Gifts for Cooks

Make inexpensive gifts by burning on store-bought kitchen tools

By Michele Parsons

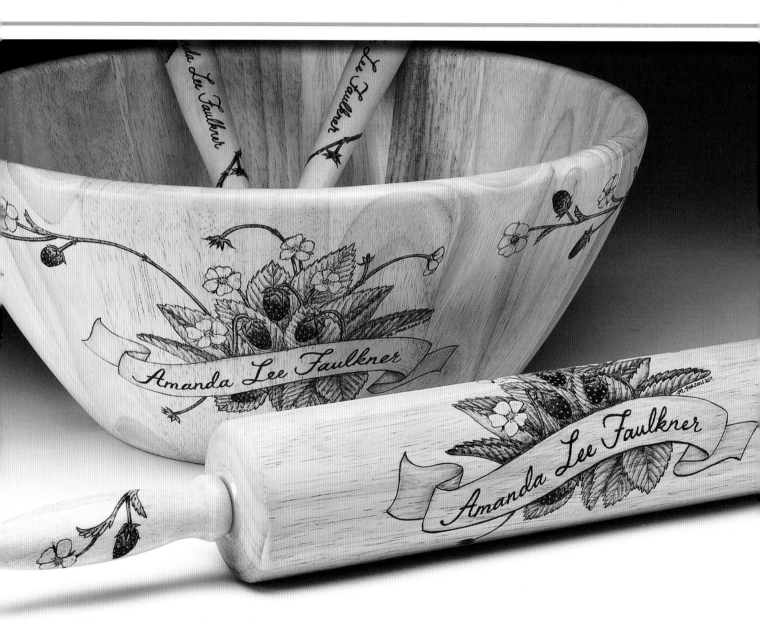

I like to create personalized gifts so they are more meaningful to the recipient. Wooden kitchen items are inexpensive, readily available, and easy to personalize with pyrography. The designs can be universal, such as flowers, herbs, fruits, and vegetables, or specific to the person, such as paw prints for an animal enthusiast. I might simply tie a ribbon around a group of personalized spoons, or make a more elaborate gift by adding local cookbooks, homemade baked or canned goods, kitchen linens, or fruit.

Adjusting the Pattern

Photocopy the pattern to a size that will closely fit the wooden item. Trim the copied pattern next to the design to eliminate excess paper and test-fit it by taping the pattern to the item. When using a spoon pattern that has a spiraled handle design, tape the pattern to the end of the handle, and then spiral it down the handle and tape the spoon bowl design over the bowl.

• Determine where the pattern needs to be lengthened or shortened and where elements need to be moved or turned to fit the item. Cut the pattern so you can make these adjustments. Tape all adjustments with clear tape and photocopy the adjustments as your new pattern.

• To bend a computer-generated name to fit in a curved area, print the name and closely trim around it. Cut slits on the top and bottom of the paper between each letter—cutting close, but not through the center. Bend the name to fit the curve. Trim or overlap edges so each letter shows. Tape the curved name using clear tape and photocopy the bent text to create a pattern for transfer.

Preparing the Surface

Prepare the surface of the wooden item by completely sanding off any finish or any manufacturing name or logo that might interfere with the design. Once the wooden item is free from finishes and blemishes, lightly sand it with 220-grit or finer sandpaper. Only burn on natural surfaces to avoid breathing the toxic fumes that paints and finishes may create. Use a small fan blowing in the opposite direction to pull woodburning fumes away from you, and do not lean over the item while burning. Some exotic woods can cause allergic reactions when burned. If your item is not a common wood, burn it outside.

Photocopy the pattern at a size that will fit on the item and make any necessary adjustments. (See Adjusting the Pattern, at left.)

If you have nice handwriting, you can write your recipient's name in pencil on the item after you transfer the design. Otherwise, use a computer to type the name of the recipient and select an appropriate font and size for the item and design. There are several free font companies online, many of which allow you to type sample text and preview the font before you download. Two of the sites I use are www.1001freefonts.com and www.fonts101.com.

TIPS

TESTING THE HEAT SETTING

When using store-bought wooden items, you will not have the luxury of having matching wood for testing temperature settings unless you buy an additional item. You can avoid buying a sacrificial item by starting to burn with a setting you know is too low and gradually increasing the temperature until you reach the desired burn color. Do this in an obscure area that can be easily disguised—a busy part of the design or an area that will eventually be burned darker.

AVOIDING ERRORS

Double check that you have spelled the recipient's name correctly! The worst thing you can do is spend hours making a gift only to find out they spell their name differently.

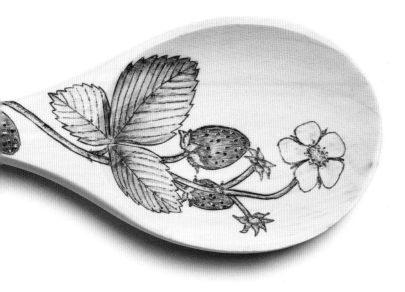

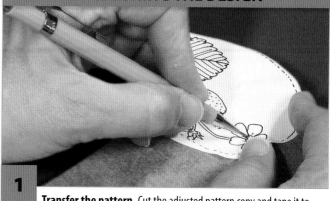

1 **Transfer the pattern.** Cut the adjusted pattern copy and tape it to the spoon so it will not shift. Starting at the end of the handle, slide graphite paper beneath the design, trace with a pencil or pen, check the transfer (dark enough to see, but light enough to erase), tear off the completed pattern portion, adjust the tape, and touch up the transferred lines with a pencil. Move to the next segment down the handle and repeat until the entire design is transferred. Add the recipient's name.

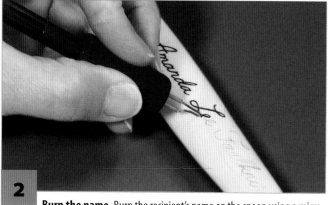

2 **Burn the name.** Burn the recipient's name on the spoon using a micro writing tip. Make the letters dark and even in tone. Wooden cooking items darken with use. To maintain definition, avoid adding background shadows around the design components. Burn with strong contrast and good solid darks so the design will last over time.

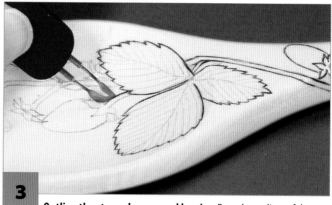

3 **Outline the stems, leaves, and berries.** Burn the outlines of the stems, large leaves, and berries using a skew tip. Burn the tiny leaves where the berries attach with a micro writing tip.

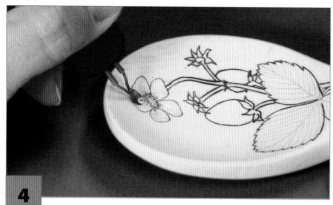

4 **Burn the flowers.** Strawberry flowers are white, so lightly burn the outline of the petals using a micro writing tip. Burn the center of the flower with a light tone. Add dark stippling (dots) around the flower center. Using a shader tip, add just a hint of shading on the center of the petals where they attach and across the top outer edges.

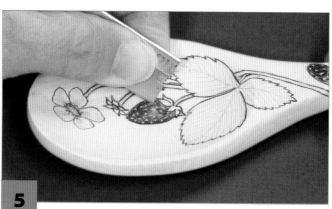

5 **Burn the berries.** Use a shader tip to color the strawberries a medium brown all over. Adjust the temperature a little higher and burn the berries darker along the bottom and sides, blending toward the center. The result should be dark brown berries with a subtle highlight. Use a razor blade to add seeds by sticking the blade corner in the wood and flicking it out until the natural color of the wood appears.

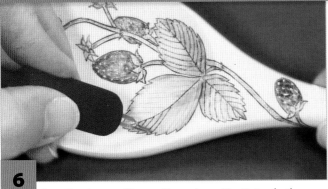

6 **Burn the stems and leaves.** Use a micro writing tip to color the stems and leafy berry tops. Shade the stems pale in the center and a little darker on the sides. Use a shader tip to shade the large leaves a light honey color all over. Start at the tips of the leaves and pull in to the center vein, following the direction of the leaf veins. Then, shade portions of the leaves a little darker following the tonal pattern. Use a micro writing tip to draw the leaf veins.

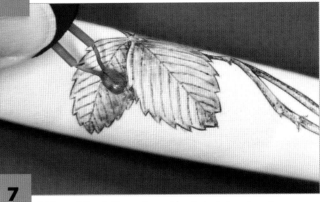

7 **Add tonal depth.** Use a micro writing tip to darken along the bottom inside edge of the stems (spoon bowl side) and on the bottom stem where two stems overlap. Add an almost black dot next to each white seed dot in the 7:00 position. Use a shader tip to add the darkest tones to the leaves, following the tonal pattern.

8 **Sign and date your work.** Using a pencil, sign your name (or initials) and write the date in an obscure place, and then burn over the pencil lines using a micro writing tip.

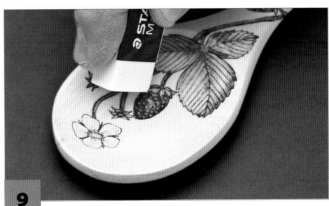

9 **Clean up the project.** Erase all transfer and pencil lines. Use the edge of a razor blade to scrape any edges that are bumpy and any dark splotches in the shading.

Working with Large, Round Items

Woodburning large, round items creates a challenge for hand support, but fortunately there are several methods for resolving this challenge.

Build up the area around the item to provide the needed hand support. When working with a rolling pin or similar item, fold a thick bath towel in half lengthwise, place the rolling pin in the center, roll the ends of the towel to the rolling pin, and secure each side with a large rubber band. The towel should come up to almost the top of the rolling pin, becoming a hand rest as you work on the top edge. Rotate the rolling pin as needed while burning. Or, instead of a towel, clamp blocks of wood to either side of the rolling pin.

To work on the outside edge of a large bowl, sit close to a table and put the bowl in your lap. Align the top edge of the bowl with the table top so you can use the table to support your hand as you work around the edge of the bowl. If the bowl is extra large, you may need to place a box on the table to align with the bowl edge and support your hand. Avoid raising your hand past the point of maintaining a comfortable position.

When you're not able to construct a support for your hand, you can gain hand support by extending the pinky of your writing hand and using it to contact the object. This takes practice and can be tiring, but once you become comfortable with the position, it gives you more flexibility when working with round items.

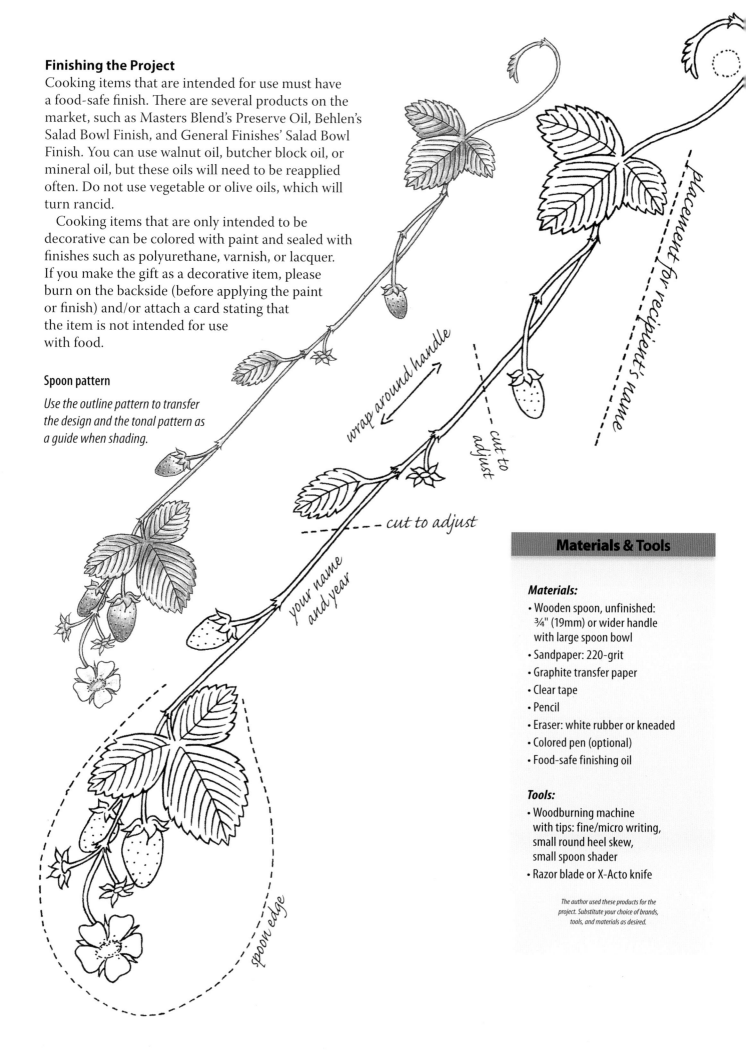

Finishing the Project

Cooking items that are intended for use must have a food-safe finish. There are several products on the market, such as Masters Blend's Preserve Oil, Behlen's Salad Bowl Finish, and General Finishes' Salad Bowl Finish. You can use walnut oil, butcher block oil, or mineral oil, but these oils will need to be reapplied often. Do not use vegetable or olive oils, which will turn rancid.

Cooking items that are only intended to be decorative can be colored with paint and sealed with finishes such as polyurethane, varnish, or lacquer. If you make the gift as a decorative item, please burn on the backside (before applying the paint or finish) and/or attach a card stating that the item is not intended for use with food.

Spoon pattern

Use the outline pattern to transfer the design and the tonal pattern as a guide when shading.

placement for recipient's name

wrap around handle

cut to adjust

cut to adjust

your name and year

spoon edge

Materials & Tools

Materials:
- Wooden spoon, unfinished: ¾" (19mm) or wider handle with large spoon bowl
- Sandpaper: 220-grit
- Graphite transfer paper
- Clear tape
- Pencil
- Eraser: white rubber or kneaded
- Colored pen (optional)
- Food-safe finishing oil

Tools:
- Woodburning machine with tips: fine/micro writing, small round heel skew, small spoon shader
- Razor blade or X-Acto knife

The author used these products for the project. Substitute your choice of brands, tools, and materials as desired.

Embellishing Beads

Make interesting wearable art by burning a commercial bead

By Sue Walters

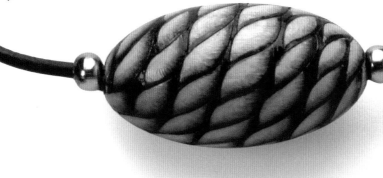

Have you ever thought about burning on beads? You can find inexpensive wooden beads in most craft stores, and with a bit of work, you can turn them into functional, wearable pyrography. They make great gifts and could become a nice little money earner.

Bead burning can be an addictive, bite-sized burning project that will have you absorbed for hours on end. Or, if you prefer, this design can be used on many other projects. For instance, it would make a great border on a picture frame.

I started by practicing a basic rope pattern on a flat board and then transferred the pattern to a bead.

Rope pattern

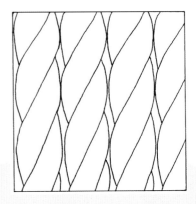

PRACTICE BOARD: BURNING A BASIC ROPE PATTERN

1. Outline the rope pattern. Use graphite paper to transfer the pattern to the practice board (see page 106). Use a narrow tip, such as a skew or a writing tip, to burn just along the edges of the rope strands.

2. Begin shading the strands. Using a writing or shading tip, burn a soft, dark shadow line below the lines separating the rope strands.

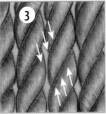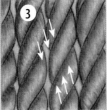

3. Shade the rope. The goal is to make the strands look round. Burn a series of abutting lines starting from the dark shadow line. Taper these lines toward the middle of each strand. If your rope is large enough, a shader is the ideal tip to burn these soft, tapering lines. If your project is small, use a writing tip. For additional realism, burn a series of soft, tapering abutting lines from the bottom of each strand if there is enough room to accommodate both shadows.

4. Darken the spaces between the ropes. Use a writing tip to darkly burn the gaps between the ropes. This provides a strong contrast and helps make the ropes stand out clearly.

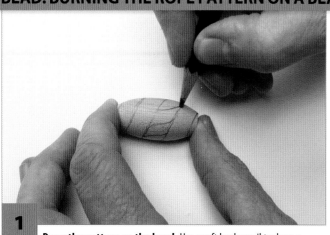

1 **Draw the pattern on the bead.** Use a soft lead pencil to draw a wide spiral around the bead. Draw a second spiral between the first spiral lines. If you want a thinner rope, divide the spiral again until you get the thickness of rope that you desire. Use the pattern as a guide to draw the strands.

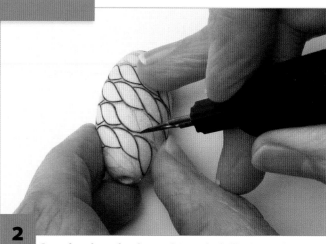

2 **Burn the edges of each strand.** I use a knife-like skew tip, but you can use a writing tip.

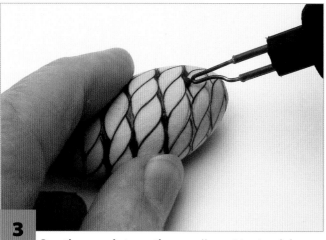

3 **Burn the spaces between the ropes.** Use a writing tip to darken the voids between the ropes. For the beads, I find it easier to visualize if I burn the spaces between the ropes at this point.

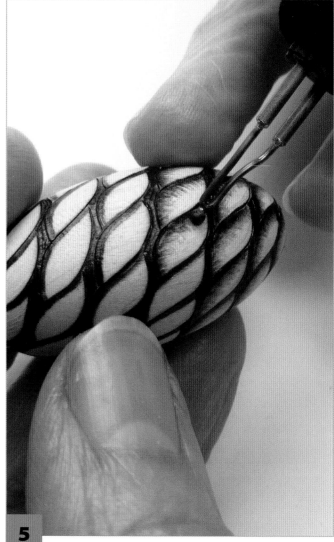

4 **Darken the lines between the individual strands.** Using a writing tip, deepen and expand the dark line between each wrapped strand of rope.

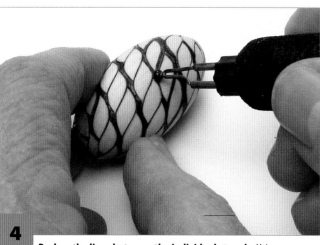

5 **Shade the rope.** Burn soft abutting lines that start at the shadow line and taper toward the middle of each segment. Let each stroke taper off to produce a fade away effect.

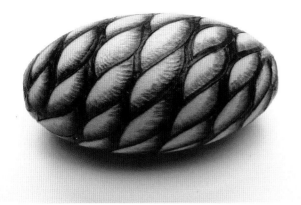

Finishing the Project

Spray the finished bead with several coats of glossy spray varnish. Your local craft or bead shop will have all the cord and findings needed to present your wearable pyrography.

Materials & Tools

MATERIALS:
- Wooden bead:
 2" (51mm)-long oval
- Scrap practice board
- Spray varnish: glossy, satin, or matte
- Cord and necklace findings

TOOLS:
- Woodburner with tips:
 shading, writing, skew
- Basic pyro kit
 (see page 101)

The author used these products for the project. Substitute your choice of brands, tools, and materials as desired.

Variations

This project should get you started creating unique original jewelry. Apply any repetitive woodburning design to different size wooden beads—the possibilities are limitless.

Burning Wood Bangles

Make a bracelet today, wear it— or gift it—tonight

By Simon Easton

Need a quick gift, easy craft show item, or fun accessory for yourself? Burn a bangle! You'll find inexpensive wooden bracelets at craft stores, or you can cut your own using a scroll saw. Simply sand the bangle with fine-grit sandpaper, wipe it with a rag or tack cloth, and you're ready to burn.

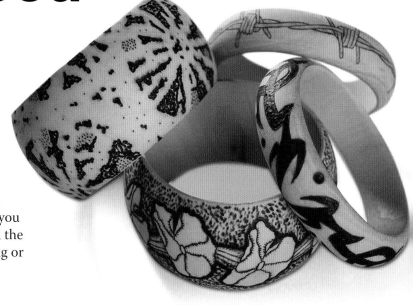

BANGLE: BURNING THE BRACELET

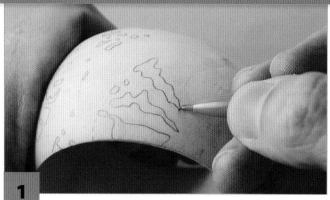

1 **Draw the design.** Select a pattern and copy it onto the bangle using graphite transfer paper. Or, draw a freehand design onto the bangle.

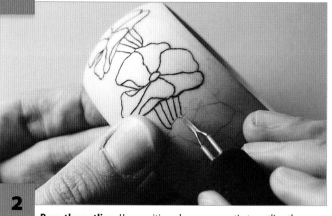

2 **Burn the outline.** Use a writing, skew, or spear tip to outline the design. Keep a firm hold on the bangle but keep the hot tip away from your fingers. When you have finished the outline, erase any remaining pencil marks.

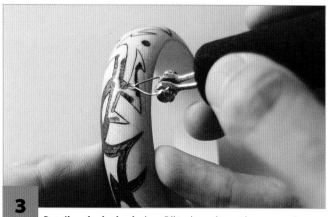

3 **Detail or shade the design.** Fill in the outline with texture and accent it with shading. If desired, use stamp tips to further decorate the bangle, incorporate a name into the design, or paint the bangle when you're done burning it.

Finishing the Bangle

When you are done burning the design, use a soft cloth to rub paste wax over the entire surface of the bangle. Use a dry cloth to buff the wax to a shine. Your bangle is ready to wear and enjoy.

Materials & Tools

Materials:
- Wooden bangle
- Sandpaper: 180- or 220-grit
- Graphite transfer paper
- Paste wax

Tools:
- Pyrography machine and tips/ pens: writing, skew, or spear; shading; assorted
- Pencil
- Artist's eraser
- Soft cloths

The author used these products for the project. Substitute your choice of brands, tools, and materials as desired.

Bangle bracelet
patterns

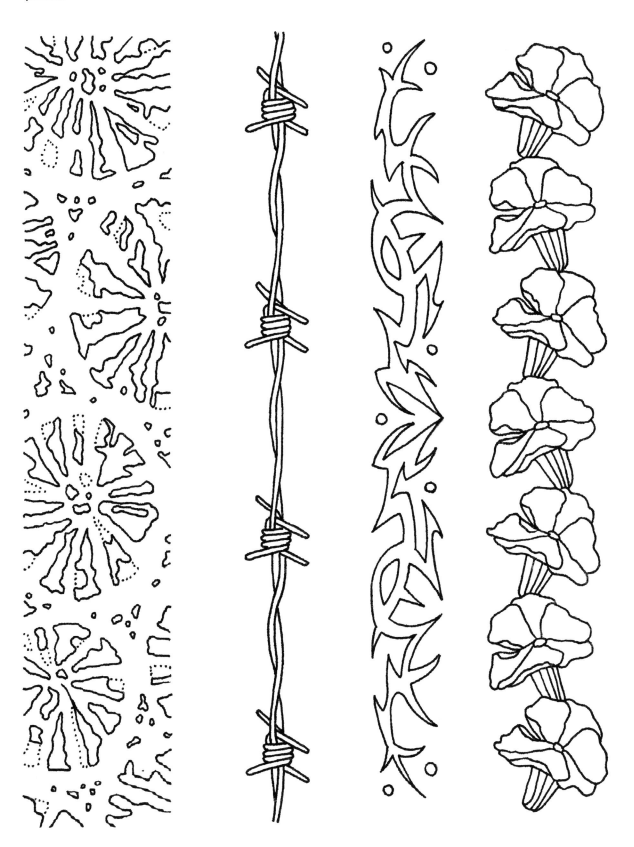

Creating a Pyrotangle Necklace

Turn tangles into wearable woodburned art

By Jo Schwartz

Zentangle® and Zentangle-inspired artwork are extremely popular. At its root, Zentangle combines meditation with the creation of artwork by drawing and shading patterns, called tangles, on squares of paper, called tiles. Traditional Zentangle is restricted to black-and-white design on tiles; anything outside that framework is considered Zentangle-inspired artwork.

I fell in love with Zentangle and have started incorporating it into my woodburned designs. I usually draw tangles onto a blank and then burn them for a more permanent or wearable design.

Making a Necklace

Sand the surface and edges of a wooden disc smooth with fine-grit sandpaper. Lightly draw tangles onto the disc, using Zentangle books and websites for reference if needed. I like to mix and match the patterns; I never make the same design twice. Here, I used traditional spirals, dots, and paisleys; Cubine; Huggins; and elements of Ennies. Burn the designs into the wood using tips that fit your design; I usually use a spear shader and a small ball tip.

After you finish burning, apply at least two coats of Mod Podge, sanding lightly between coats. Allow the piece to dry fully, and then drill a small hole for a jump ring. Thread a cord through the jump ring, and add whatever beads you want to the cord next to the pendant. Finish the necklace with a sliding bead closure or a toggle clasp.

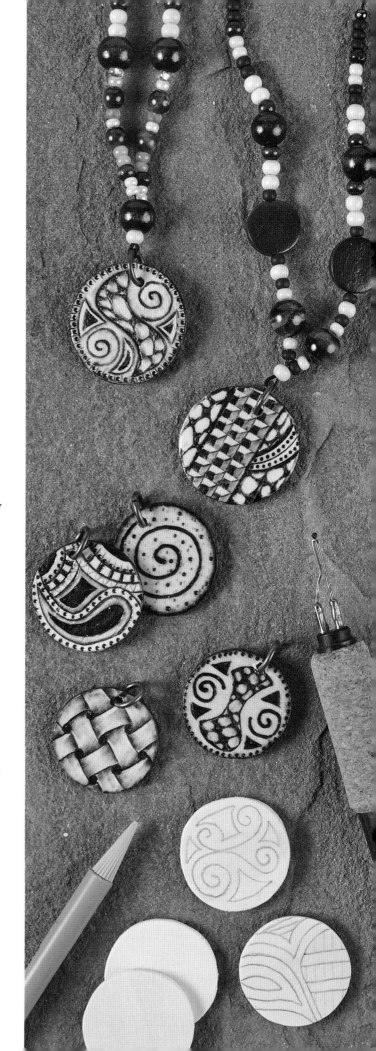

Tangles, top to bottom: Simple spirals with "pebbles" from Ennies; Ennies and Cubine; a spiral; a paisley; spirals and Ennies; Huggins.

Pyrotangle patterns

Cubine Tangle pattern

Huggins Tangle pattern

Ennies Tangle pattern

Materials & Tools

MATERIALS:
- Italian popular plywood, ⅛" (3mm) thick: 1 ½" to 2" dia. (38mm to 51mm)
- Sandpaper: fine grit
- Leather cord, ⅟₃₂" (1mm) dia.: 35" (889mm) long
- Toggle clasp
- Beads: assorted, size 6 or larger
- Jump ring: 10mm heavy gauge
- Pencil and white polymer eraser

- Waterbased sealer, such as Mod Podge: matte finish

TOOLS:
- Woodburner with tips: spear shader, 1.5mm ball tip
- Drill with bit: sized to fit jump ring
- Brushes

The author used these products for the project. Substitute your choice of brands, tools, and materials as desired.

Techniques for Burning on Cork

Learn the tricks for turning cork into interesting pyro projects

By Michele Parsons

You might not think to burn on cork because of its bumpy and soft texture, but I find the tactile feel of cork makes wonderful and different projects. Cork is a green product in that harvesting it does not kill the tree. It is versatile, too; cork can be bought in tiles, sheets, and rolls, die-cut as coasters, or adhered to objects like bulletin boards. Cork is typically thin when adhered to an object and thick when sold in tiles, sheets, or rolls. Plus, I have seen products likes lamps, placemats, purses, and bowls made from cork. Look for chemical-free cork for pyrography projects.

To burn successfully on cork, you will need to adjust your techniques slightly. Practice these methods on scraps of cork, and then use them to make a cheery burned bulletin board with optional color.

Woodburning Nibs

Skew, writer, and shader nibs all burn well on cork. However, there are some differences in burning on cork rather than wood:

- The writer and skew nibs burn slightly faster on cork than on basswood at the same temperature.
- The shader nib burns much faster on cork than on basswood, so you should use a much lower temperature for burning cork.
- The writer and shader nibs burn soft-edged and grayish-brown in color, whereas the skew nib burns sharp-edged and dark brown.
- Writer nibs tend to burn a wider stroke on cork than on wood due to the spongy nature of cork's surface. Use a narrower nib to get the same effect as on wood.
- Cork tends to behave like wood end grain, so to make smooth curves and circles with a writer nib, lighten the pressure while burning.
- When burning with a skew on thin cork, keep the pressure light so you don't burn through to the glue adhesive or substrate below the cork.

Transferring a Pattern

Transferring a pattern onto cork is more difficult than onto wood because of the cork's sponginess. I use a charcoal pencil or all-surface pencil to draw patterns directly onto the cork. If you choose to use graphite paper to transfer the pattern, use a light but firm pressure and transfer just the larger shapes and minimal details. I did not have any success using the mineral spirit transfer method with cork. However, I found that printing the pattern on pyrography paper (a translucent tracing paper) and then burning the image through the paper was very successful.

Fixing Mistakes

A white rubber eraser removes both graphite and charcoal marks on cork. Take care not to rub hard or you can create a hole in the cork or a bubble under it. If a bubble forms, fix it by slicing next to the lines of the design with a razor blade, lifting a flap of cork, and applying glue (rubber cement) underneath.

Touching up stray lines or color with a razor blade is also difficult because the cork is spongy and granules can tear off. Keep the razor blade at a very low angle and scrape slowly, watching for signs that the cork is tearing.

Coloring Your Cork

Markers and dyes work really well to color a cork burning. For subtler color, use wax- or oil-based colored pencils, like Prismacolor pencils. You can also paint cork, but the pigment will obscure the burning, so thin it to a wash.

Getting Started

Cork doesn't need any surface preparation. However, if your bulletin board has a real wood frame that you plan to burn, remove the finish from the frame before you begin the project.

BULLETIN BOARD: BURNING THE DESIGN

1 Transfer the pattern. Photocopy the pattern to fit and tape it onto the bulletin board. If you are using graphite paper to transfer the pattern, leave a side without tape to slip the graphite paper underneath. Check the transfer by lifting the pattern to see if the graphite is on the correct side and is transferring well. If you are using pyrography paper to transfer the pattern, use a skew nib to outline the vine stems and leaves through the paper, and use a micro writer nib to pierce dots through the paper to outline the berries.

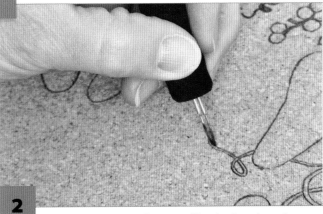

2 Outline the vine stems, leaves, and berries. Burn the outlines of the vine stems and leaves using a skew nib. To burn the round berries, use a small writing nib first and then sharpen the lines by retracing with a skew nib, using tiny segmented strokes following the outline. If you used pyrography paper to transfer the pattern, use the skew nib to touch up the outlines so the lines are even and to retrace the berries.

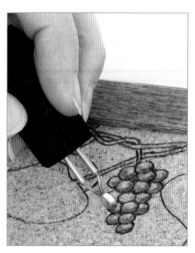
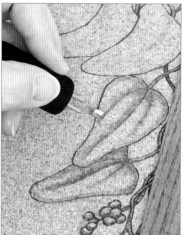
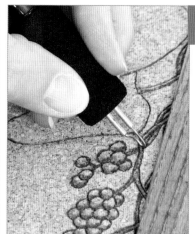

3

Add tonal depth with shading. Using a small shader nib, add shading to the berries and leaves following the pattern. Then, use the micro writer to shade the vines.

TIP

START LOW

If you do not have an extra piece of cork to test temperature settings, start the burn with a setting you know is too low and gradually increase the temperature until you reach the desired burn color. Do this in an obscure area that can be easily disguised— a busy part of the design or an area that will eventually be burned darker.

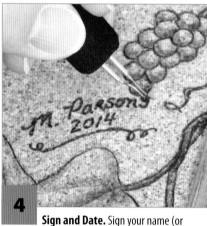

4

Sign and Date. Sign your name (or initials) and write the date in pencil in an obscure place, and then burn over the pencil lines using a micro writing nib.

5

Clean up. Erase all of the transfer and pencil lines. Use the edge of a razor blade to scrape any edges that are bumpy and any dark splotches in the shading, taking care not to tear the cork away.

BULLETIN BOARD: ADDING COLOR

6

Add color (optional). When coloring the vine pattern, I chose to use Sharpie markers and Prismacolor pencils because they produce a vibrant color that mirrors the yellow-green leaves and red berries. If you desire more muted colors, use wax- or oil-based colored pencils by themselves or acrylic washes.

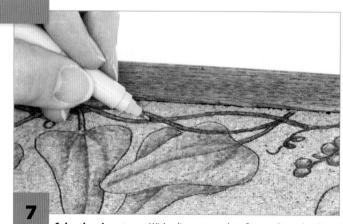

7

Color the vine stems. With a lime green ultra-fine marker, color the vine stems using a "dry brush"-like technique of scribbling back and forth along the vine. Leave some spaces uncolored to make the vines a little more subtle than the vibrant leaves.

8 **Color the berries.** Using a peach ultra-fine marker, place a dot of color for the highlight on each of the berries. The highlight should be in the same position on the berry relative to the orientation of the picture so the highlight on all of the berries appears to come from the same light source. Next, circle the berry highlights with a red ultra-fine marker. Fill the berries with a fine red marker, and then darken the berry shadows, opposite the highlight, with a dark red ultra-fine marker.

9 **Color the leaves.** Outline each leaf with a fine lime green marker, and then fill it in with light, quick, scribbling strokes in the direction of the leaf veins using the side of the marker tip.

10 **Add color dimension.** To add dimension to the leaves, use Prismacolor pencils layered over the marker colored base. Use canary yellow #916 for the leaf color between the veins and the sides of the leaf, and use peacock green #907 for the shadows and leaf veins overlapping into the yellow. Use the green pencil to tone down the yellow pencil if the yellow is too bright.

Finishing the Project

If your project bulletin board has a real wooden frame and you removed the manufacturer's finish and then burned a design on it, you will need to apply a sealing finish, such as polyurethane, varnish, or lacquer. You do not need to apply a finish to the cork.

Materials & Tools

MATERIALS:
- Cork bulletin board (with real wood frame if you want to burn on the frame): 17" x 23" (432mm x 584mm)
- Graphite (not carbon) transfer paper or pyrography paper
- Tape
- Pencil and eraser (white rubber or kneaded erasers are best)
- Coloring mediums, such as markers, colored pencils, or acrylics (optional): lime green, peach, red, dark red, peacock green, yellow
- Polyurethane, varnish, or lacquer with brushes and cleaning fluid (if burning on wood frame)
- Sandpaper: fine (if burning on wood frame)

TOOLS:
- Woodburner with pens: micro writing nib, small round heel skew nib, small spoon shader nib, small writing nib
- Single-edge razor blade

The author used these products for the project. Substitute your choice of brands, tools, and materials as desired.

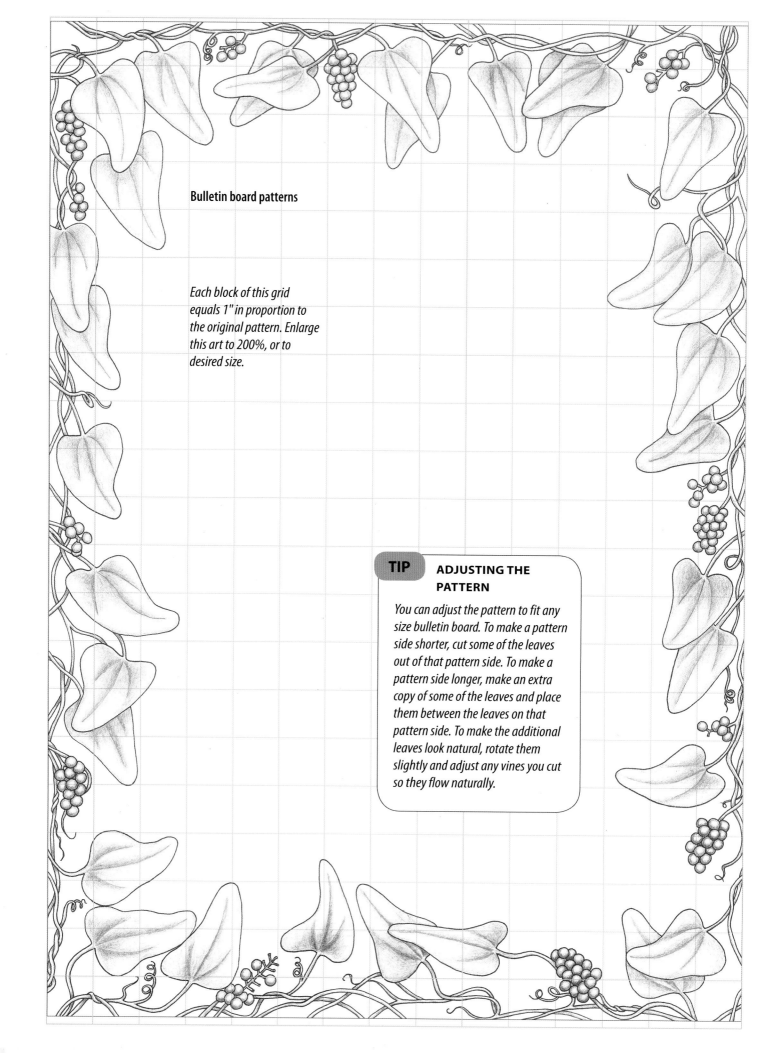

Bulletin board patterns

Each block of this grid equals 1" in proportion to the original pattern. Enlarge this art to 200%, or to desired size.

TIP **ADJUSTING THE PATTERN**

You can adjust the pattern to fit any size bulletin board. To make a pattern side shorter, cut some of the leaves out of that pattern side. To make a pattern side longer, make an extra copy of some of the leaves and place them between the leaves on that pattern side. To make the additional leaves look natural, rotate them slightly and adjust any vines you cut so they flow naturally.

Making Scrapbook Tags

Use trinkets and trash to make unique tags

By Lora S. Irish

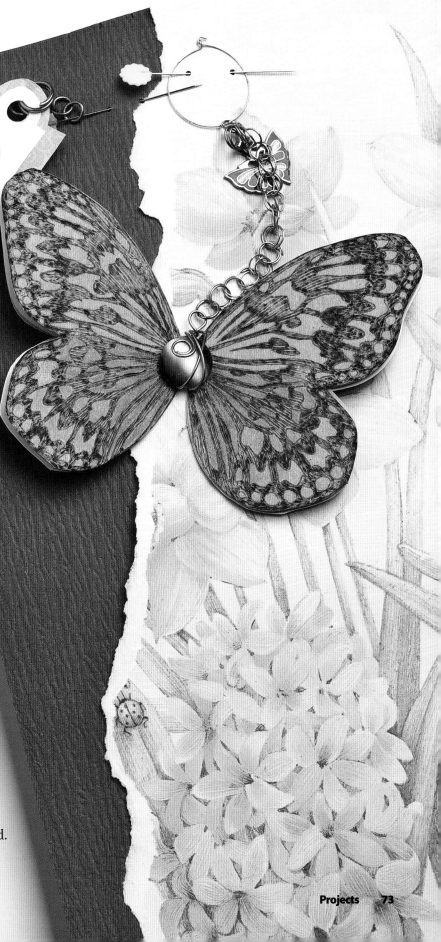

Tags are a mainstay in scrapbook layouts. They add small design areas, bright colors, and journaling space. I have a large storage box of tags that I have collected over the years, but often I cannot find the right tag for the layout I'm working on. So for me, the simple answer is to create my own.

The most commonly used papers for pyrography are watercolor paper, pastel paper, and Bristol board. You can also use heavyweight scrapbook layout paper. I prefer a non-polished solid-color paper with a matte finish and fine texture, such as chipboard. There are many sources of paper and chipboard right in your home—paper grocery bags, the backs of notebooks, shipping boxes, cereal boxes, and snack boxes. Although the outsides of these boxes may be heavily printed, the insides offer clean, easy-to-work surfaces. I made the butterfly tag from a lightweight chipboard snack box.

While you are rummaging around the house looking for pyrography materials, also keep an eye open for accents you could use to complete your pyrography tag—vintage jewelry, beads, quilting pins, key rings, fabric, and ribbon or cord.

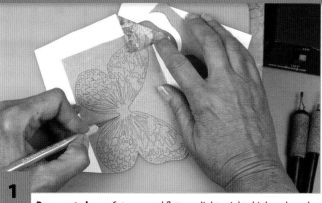

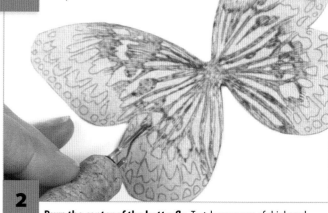

1 **Prepare to burn.** Cut open and flatten a lightweight chipboard snack box. Use graphite paper and a ballpoint pen to transfer the pattern to the clean chipboard inside the box. Use a craft knife to cut the outline of the butterfly to remove the excess chipboard. If desired, place a scrap of patterned scrapbook paper, printed side down, under the chipboard butterfly as you cut. This will create a paper butterfly to hide the printed side of the chipboard.

2 **Burn the center of the butterfly.** Test-burn scraps of chipboard to find the temperature setting that creates a medium-brown burn tone. I used a setting of 7. Using a standard writing tip, work a fine straight line pattern in the center section of the butterfly. Don't outline the spaces, just fill them with fine lines.

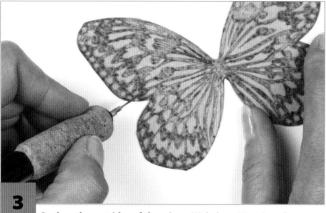

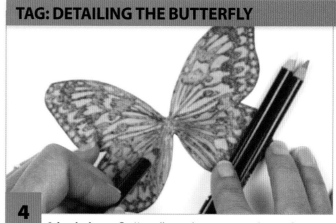

3 **Darken the outsides of the wings.** With the writing tip and the same temperature, use short scrubby strokes and slow movement to create very dark chocolate tones for the outer wing edges. Burn the dark tone to the edge of the wings. Glide the woodburning tip along the cut edge of the chipboard to smooth any rough areas left from the cutting process.

4 **Color the butterfly.** Use yellow and orange watercolor pencils to lightly color the central area of the butterfly wings. Work in a layer of red over the orange, next to the wing joint area.

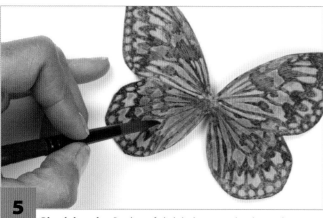

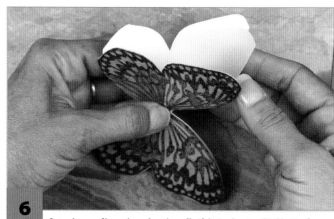

5 **Blend the color.** Brush a soft, lightly damp paintbrush over the color to smooth and blend it. The colors will be transparent when dry so the pyrography will show through. Set the tag aside for a few minutes to dry.

6 **Cut a journaling piece (optional).** If desired, cut a third butterfly shape out of vellum paper to use for hidden journaling. Using a small spot of craft glue at the wing joint area of the butterfly cutouts, glue the three layers of paper together. Allow the glue to dry for about a half-hour.

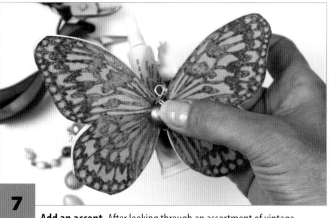

7

Add an accent. After looking through an assortment of vintage jewelry bits, I chose to decorate my butterfly tag with a blue glass pendant that has a wire loop at the top. I adhered it with jewelry cement and let the cement set.

Finishing the Tag

To complete my tag, I attached a small section of necklace chain to the center glass bead and strung the chain on a pierced-earring hoop. I also added a butterfly charm to the earring hoop. Finally, I anchored the hoop to the layout with flowery quilting pins, which allow the butterfly tag to swing freely.

The butterfly chipboard tag took me about an hour to complete, most of which was drying time; cost nothing; and is exactly what I wanted for this layout. Plus, while I waited for the glues to thoroughly dry, I made several more fun little chipboard tags.

Scrapbook tag pattern

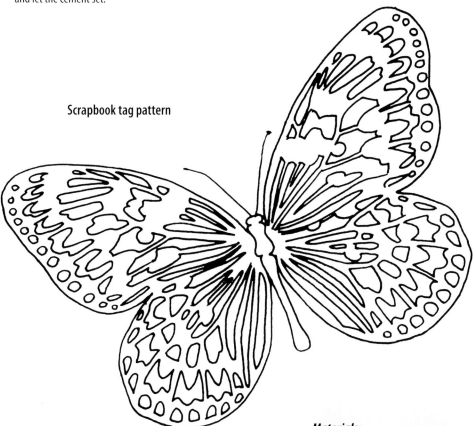

Materials:
- Chipboard, such as a snack box: 3" x 5" (76mm x 127mm) piece
- Graphite paper
- Watercolor artist pencils: yellow, orange, red
- Craft glue
- Jewelry cement or two-part epoxy glue
- Scrapbook paper (optional)
- Vellum (optional)
- Vintage jewelry, charms, beads, etc.

Materials & Tools

Tools:
- Woodburning machine and tip: standard writing
- Scissors
- Ballpoint pen
- Craft knife
- Paintbrush

The author used these products for the project. Substitute your choice of brands, tools, and materials as desired.

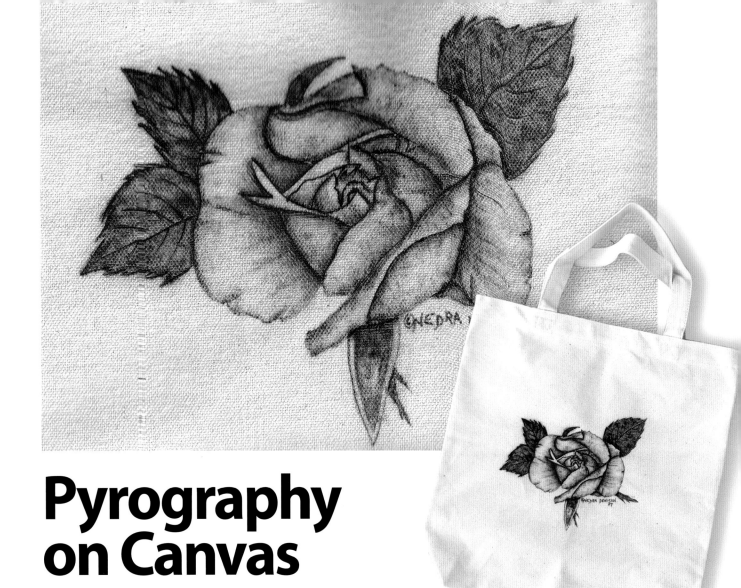

Pyrography on Canvas

Simple advice for burning on—but not through—cloth

By Nedra Denison

Like most new burners, when I started pyrography I thought the only thing you could burn on was basswood. As I learned and mastered the techniques, I gained more confidence and decided to experiment, first on leather and then on wood with grain. I also tried maple burls, which were even more enjoyable. My last experiment was on canvas, and that was a challenge.

Safety

In my classes and online tutorials, I stress the importance of burning on materials that are not prepared using any sort of chemicals, which can be toxic when heated. That means no stain, dye, paint, sealer size, or treatment of any kind. It also means burning on safe materials (i.e., not burning on plastic, glue, etc.). So, for this project, be sure to use untreated canvas.

Preparing the Canvas

The untreated canvas bag I found was thick and heavily textured, so it was challenging but not impossible to burn. It would be easier to work on untreated canvas that is thin. The canvas that artists paint on is ideal, but make sure it has not been treated in any way.

Use a steam iron to flatten the canvas bag so you don't have to fight wrinkles. Place graphite paper under the pattern and trace it onto the canvas with a pen, fine (0.8mm) stylus, or a mechanical pencil.

While I'm burning, I refer to a black-and-white copy of the pattern photo as a guide for tonal values. I also glance at a color copy to give me an idea what the design looks like in color, because my goal is to create the illusion of color rather than actually coloring the burning. I prefer burnings to be "au naturale."

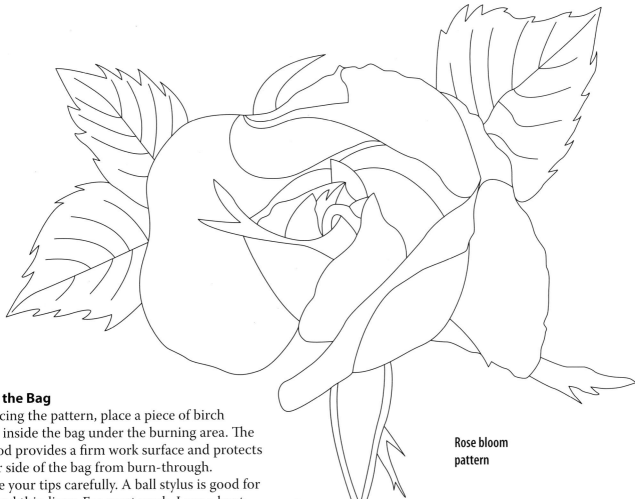

Rose bloom
pattern

Burning the Bag

After tracing the pattern, place a piece of birch plywood inside the bag under the burning area. The hard wood provides a firm work surface and protects the other side of the bag from burn-through.

Choose your tips carefully. A ball stylus is good for writing and thin lines. For most work, I use a bent spear shader. Avoid sharp tips, such as a skew, because the sharp edge can slice the canvas.

I always burn using a moderate temperature rather than trying to create the dark tones in one stroke. This technique allows me to control the tonal values and, in this case, it also keeps me from burning through the fabric. I layer the strokes until I get the depth of color I want. It's always easier to add than it is to take away, especially because you cannot erase canvas like you can wood. Start with the lowest layers and burn on top, just as the flower grows.

The key to burning on canvas is to relax and slow down. Don't try to rush using a high heat, because you will only end up scorching or burning a hole through the canvas. This is critical when working on thinner canvas. Thick canvas will tolerate a little more heat.

Adding Color

If you decide to color your burning, you can use oil, acrylic, or even watercolor paint on the canvas. Consider what the burning will be used for; you can experiment with display pieces, but for wearable art you should use a medium that is made for fabric. If you plan to add color, avoid deeply shading the areas you will color.

Materials & Tools

MATERIALS:
- Untreated canvas bag or piece of canvas
- Graphite paper
- Paints of choice (optional)

The author used these products for the project. Substitute your choice of brands, tools, and materials as desired.

TOOLS:
- Woodburner and tips: ball stylus, bent spear shader
- Steam iron
- Mechanical pencil, pen, or fine (0.8mm) stylus

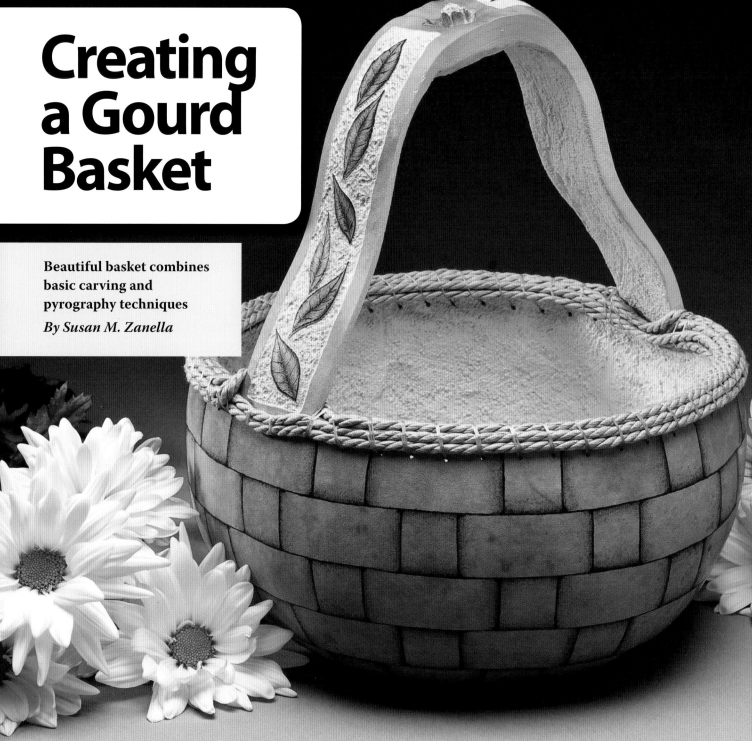

Creating a Gourd Basket

Beautiful basket combines basic carving and pyrography techniques

By Susan M. Zanella

Gourds can be a wonderful surface for pyrography. I love working on a 3-D object instead of a flat surface. Although a gourd surface can be a challenge, the uniqueness of the gourd is part of its charm. This gourd basket with the look of plaiting is a fairly easy burning project but, depending on the size of your gourd, it can be quite time-consuming.

I buy most of my gourds from two Amish farmers in the Lancaster, Pa., area. I usually buy them with the outside already cleaned, which saves time and allows me to really see the gourd I am purchasing. I especially

check for blemishes that would make the gourd unsuitable for pyrography. There are many sources for gourds online; visit the American Gourd Society's website for a list (AmericanGourdSociety.org).

Gourd mold and dust can be extremely harmful. I strongly suggest you use eye protection and a good quality respirator when burning and carving gourds.

My Martin gourd is approximately 9½" tall and 8½" wide at the widest point. You'll need to adjust the sizes to fit your gourd.

1 Sand the gourd. Start by lightly sanding the entire surface of the gourd to remove blemishes and slight imperfections, and to create a smoother working surface. I use a 3-D Sander, but any fine-grit (800 or higher) sandpaper will do the job.

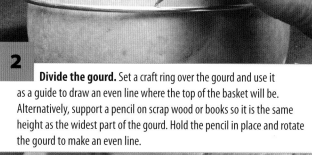

2 Divide the gourd. Set a craft ring over the gourd and use it as a guide to draw an even line where the top of the basket will be. Alternatively, support a pencil on scrap wood or books so it is the same height as the widest part of the gourd. Hold the pencil in place and rotate the gourd to make an even line.

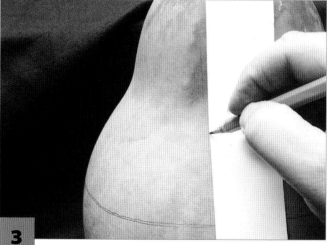

3 Draw the basket handle. Using a strip of paper cut to the width of the handle (I used 1½", or 38mm) as a guide, draw the basket handle.

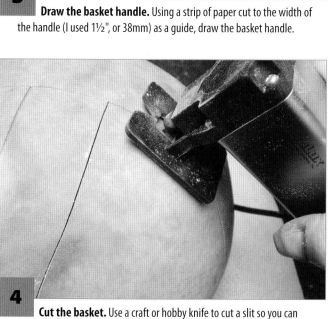

4 Cut the basket. Use a craft or hobby knife to cut a slit so you can insert the saw blade. Then, use a mini jigsaw or standard hand saw to cut the handle and basket on both sides of the gourd.

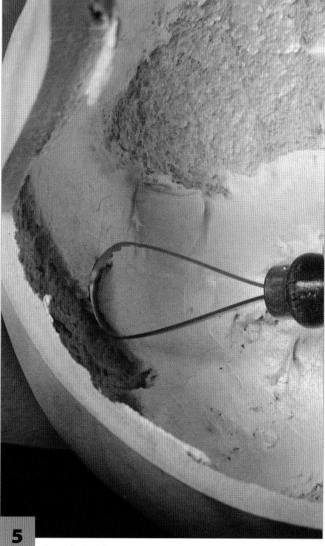

5 Clean the inside. Once the gourd is cut open, remove the seeds and pulp, and clean and sand the inside surface. I use a hand-held gourd scraper to remove the inside skin before sanding the interior.

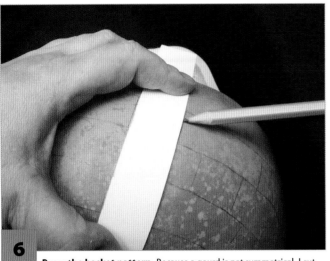

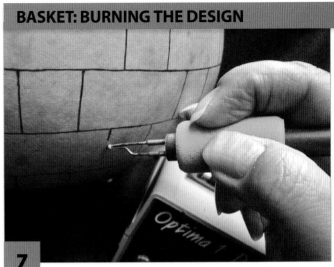

6 **Draw the basket pattern.** Because a gourd is not symmetrical, I cut pieces of paper to use as guides for drawing consistently spaced lines. My basket has 1" (25mm)-wide horizontal weavers, ¾" (19mm)-wide vertical spokes, and a 2" (51mm)-wide space between spokes. The vertical spokes alternate on each row so they appear to weave. Adjust the shapes and sizes as necessary to look nice on your gourd. Draw several leaves down each side of the handle.

7 **Burn the outlines.** Using a small ball tip, outline the entire woven pattern and the leaves. Lightly draw veins on the leaves.

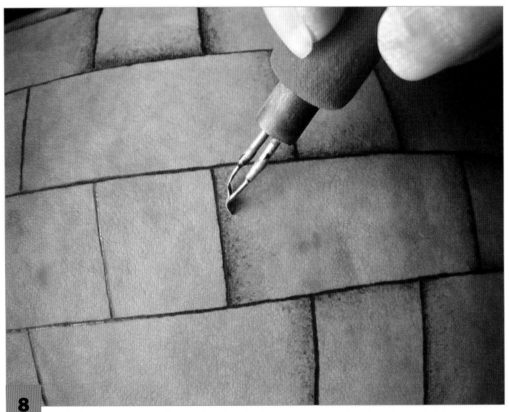

Figure A

Figure B

Figure C

8 **Shade the woven pattern.** Use a feather edger tip, a low temperature, and crosshatching. Start at the vertical outline of a spoke. First, shade with a series of small, quick 45° lines going down and out from the line (Fig. A). Then, cross those lines with a series of small, quick 45° stokes going up and out from the line (Fig. B). Cross a third time with hatches that go straight out from the line (Fig. C). Each time, extend the lines a little farther out; the hatching closest to the outline will be the most dense and therefore appear darker. Finish with a light scrubbing motion to smooth the lines and create even shading. Refer to the photo and repeat the shading on the entire basket.

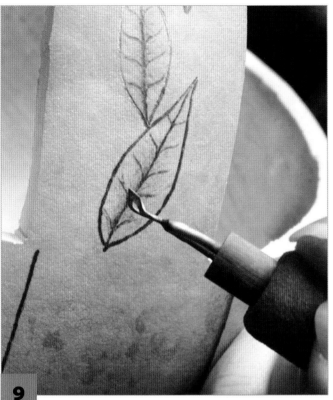

9 **Shade the leaves.** Using a feather edger tip and following the instructions in Step 8, shade the centers and edges of the leaves. When you are satisfied with all shading, remove the pencil lines from the gourd by wiping the entire surface with a baby wipe or a wet paper towel.

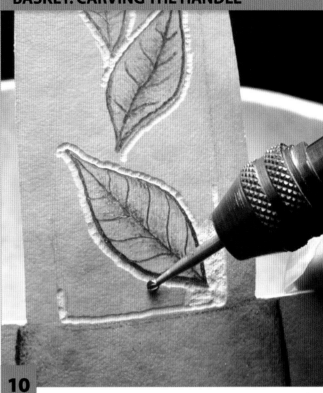

10 **Carve the handle.** Lightly draw a box around the leaves. Very carefully use a rotary-power tool and a ⅟₁₆" (2mm)-diameter ball-shaped high-speed steel cutter to outline each leaf and the rectangular box. Change to a ⅛" (3mm)-diameter ball-shaped cutter to carve larger sections, aiming to remove just the thin outer layer of the shell and create a pitted look. Keep the speed of the rotary tool high to smoothly cut the gourd shell.

Materials & Tools

Materials:
- Gourd
- Paper
- Sandpaper: 800-grit
- Danish cord
- Heavy thread: beige
- Acrylic craft paint: cream
- White glue
- Varnish, UV protectorate, such as Helmsman® Spar Urethane
- Baby wipes or paper towels

Tools:
- Pyrography machine and tips/pens: small ball, feather edger
- Pencil
- Scissors
- Craft ring (optional, diameter to match widest point of gourd)
- Mini jigsaw, such as MicroLux, or standard hand saw
- Gourd scraper
- Mini sander, such as Craftsman 3-D Sander, and sanding disks: fine-grit (optional)
- Rotary-power carver and bits: ⅟₁₆" (2mm) and ⅛" (3mm)-diameter round balls
- Craft or hobby knife
- Paintbrush
- Drill and bit: ⅟₁₆" (2mm)
- Embroidery needle

The author used these products for the project. Substitute your choice of brands, tools, and materials as desired.

Finishing the Basket

Seal the gourd by painting the inside of the bowl and handle, as well as the edges, with a 50/50 mixture of cream acrylic paint and white craft glue. When the sealant is dry, protect the pyrography from light by spraying it with a UV protectorate varnish, such as Helmsman® Spar Urethane. Finally, drill evenly spaced ⅟₁₆" (2mm)-diameter holes around the rim of the basket and use an embroidery needle and heavy thread to sew several layers of Danish cord around the rim.

Leaf patterns for handle

Graceful Leaf Gourd

Turn a hard-shelled gourd into a bowl embellished with pyrography and inks

By Susan M. Zanella

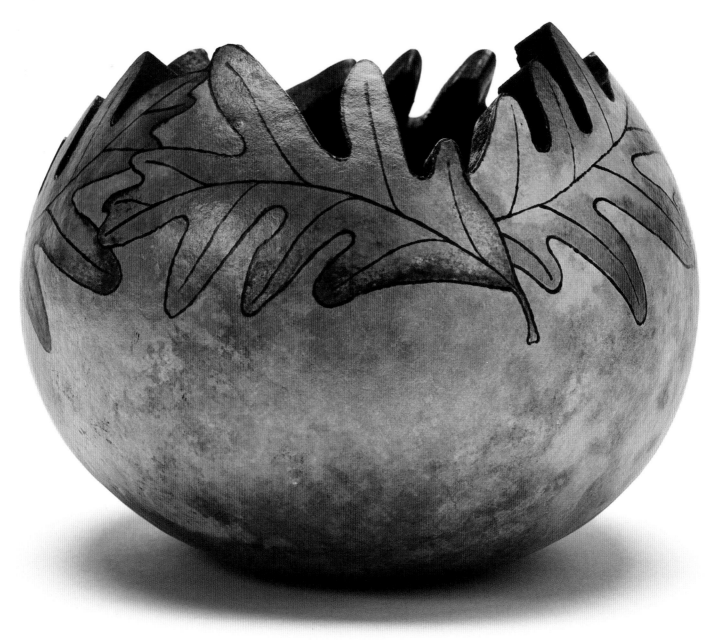

The hard-shelled gourd makes a wonderful canvas for designs ranging from simple woodburned outlines to elaborately cut out and three-dimensionally shaded patterns. Like wood, gourds have many different shapes and sizes, and each has its own challenges for burning, but the three-dimensional canvas allows for some wonderful creativity.

BOWL: SHAPING AND BURNING THE LEAVES

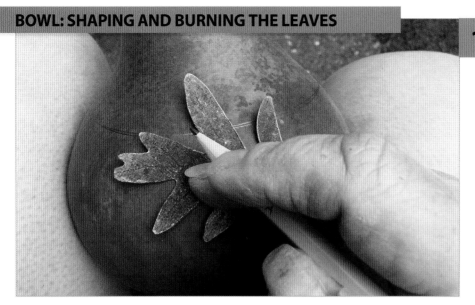

1 **Transfer the pattern and prep the gourd.** Thoroughly clean the outside of the gourd. Place a craft ring on the gourd and draw a line that indicates the approximate height of the bowl. Using the line as a guide, trace leaves around the top of the bowl. I pick leaves off trees and photocopy them onto cardstock to create custom patterns; you can also use the patterns provided. Then, roughly cut off the top of the gourd above the tips of the leaves and clean the inside of the gourd.

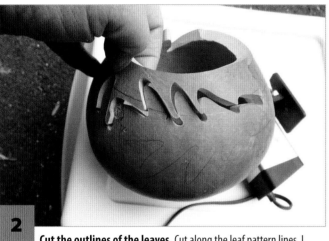

2 **Cut the outlines of the leaves.** Cut along the leaf pattern lines. I use a MicroLux mini jigsaw, which is small and easy to handle, and has an extremely tight cutting radius; it can actually double back on itself.

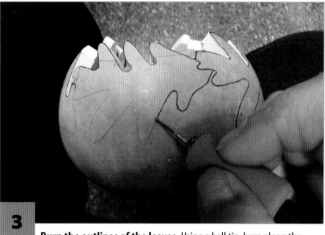

3 **Burn the outlines of the leaves.** Using a ball tip, burn along the cut edges of the leaves first, and then draw along the pencil outlines.

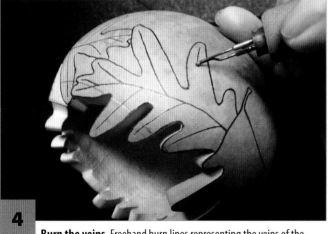

4 **Burn the veins.** Freehand burn lines representing the veins of the leaves. You can shade the leaves with the burner if you like; I left the lines simple and will add dimension using colored inks.

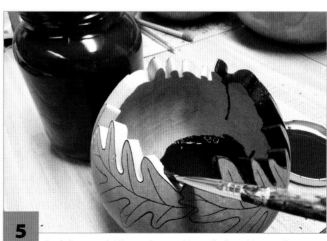

5 **Seal the gourd.** Mix equal parts white craft glue with any color of acrylic paint. Paint the inside of the gourd and the cut edges with the mixture to seal and add a background color.

I use Memories brand inks because the colors are semi-transparent and their drying time is long enough that I can blend the colors, but not so long that the colors smudge. Apply the inks with disposable micro Taklon brushes. Treat the inks as heavily thinned acrylic paint.

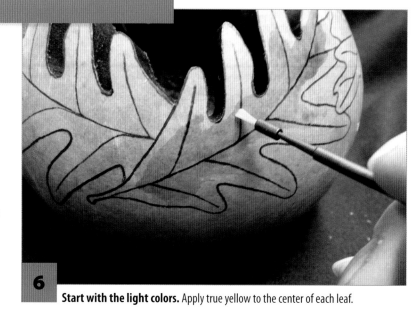

6 **Start with the light colors.** Apply true yellow to the center of each leaf.

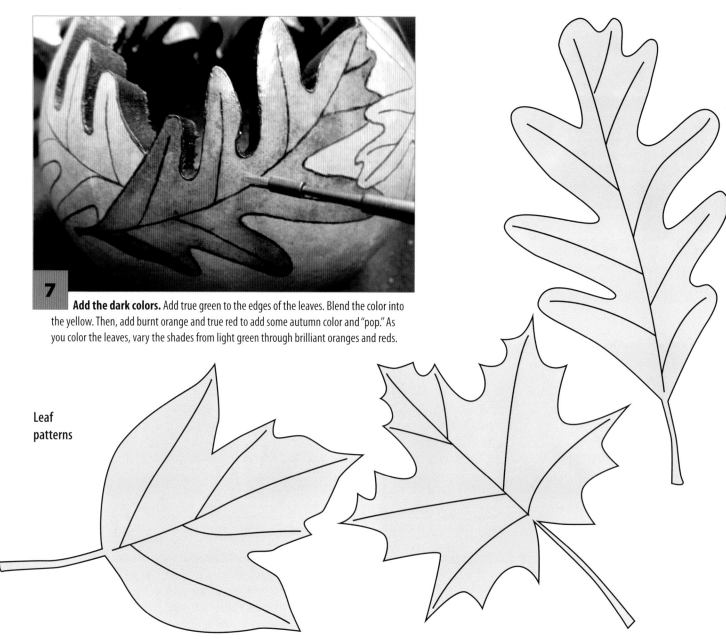

7 **Add the dark colors.** Add true green to the edges of the leaves. Blend the color into the yellow. Then, add burnt orange and true red to add some autumn color and "pop." As you color the leaves, vary the shades from light green through brilliant oranges and reds.

Leaf patterns

Variations

You can easily turn this simple bowl into a more elaborate project. Here are several variations to transform a gourd.

Cover the base of a large gourd with leaves. Burn and color the leaves, and then cut out the spaces between the leaves to create a lampshade.

For a more natural look, cut out the spaces between the leaves. Then, shade each leaf and darken the base with the burner.

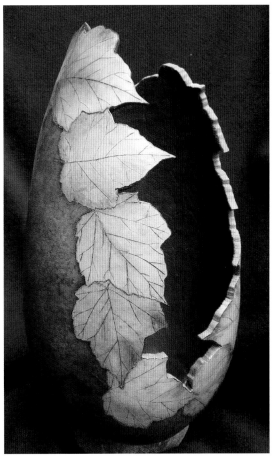

Trace the leaves in a vertical oval up the side of a tall gourd. Cut out one side and one end for a more exotic-looking sculpture.

Materials & Tools

MATERIALS:
- Hard-shelled gourd
- Leaf templates
- Acrylic paint
- Craft glue: white
- Inks, such as Memories brand: true yellow, true green, burnt orange, true red
- Disposable Taklon brushes: micro
- Basic pyro kit (see page 101)

TOOLS:
- Variable temperature woodburner with tips: ball tip
- Craft ring
- Saw, such as the MicroLux mini jigsaw
- Paintbrushes

The author used these products for the project. Substitute your choice of brands, tools, and materials as desired.

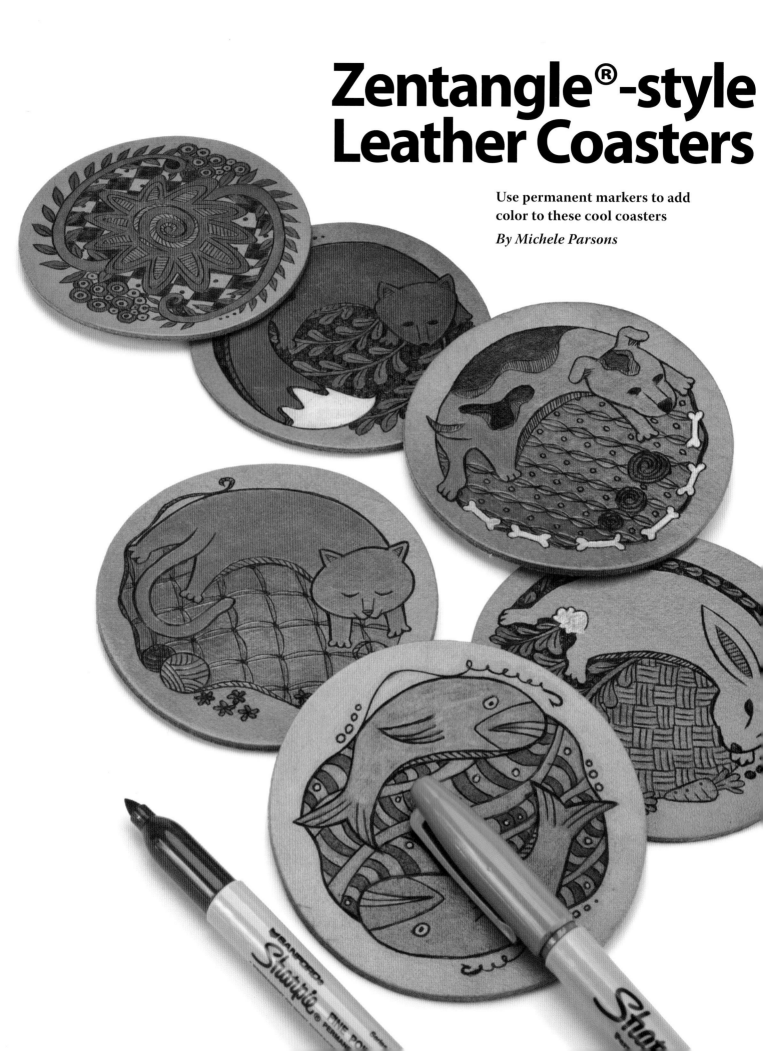

Zentangle®-style Leather Coasters

Use permanent markers to add color to these cool coasters

By Michele Parsons

Round pieces of leather, such as Leather Rounders, can be purchased precut and ready to burn, and they make unique coasters. Packaged as a set, they make great gifts. You could also cut your own leather into unique shapes to complement your design.

When selecting leather to burn, choose vegetable-tanned leather. Other tanning methods introduce chemicals that are released when you burn and can be toxic.

Burning the Design

Transfer the designs to the leather shapes, enlarging or reducing them as necessary to fit. Set the burner temperature lower for leather than you would for wood. Test the temperature of the burner on a piece of scrap leather and adjust the heat until you are satisfied with the color and depth of the lines.

Use the tips you are comfortable with to outline and lightly shade the designs. I use fine and micro writing tips, a small round-heel skew, and a medium spoon shader. Use caution with sharp tips like skews, because it is easy to slice the leather.

Adding Color

Color brings the coaster designs to life. I use Sharpie® permanent markers, which come in a variety of colors in both fine and broad tips. These markers work beautifully on leather and withstand the water coasters will be subjected to. You could also use acrylic paints to color the leather, but I suggest you thin them into a wash to keep from hiding the leather grain. For this project, I use Sharpie markers and white acrylic paint.

Embossing

Embossing the design gives a tactile feel to the coaster and makes it feel more expensive. Take a clean, damp (not wet) sponge and wipe down the coaster until it is evenly wet but not dripping water. First dampen the flesh side (grainy, suede side) and then dampen the grain side (smooth side). Allow the coaster to sit a few minutes to absorb the water. Use a stylus, burnisher, or a dried up pen that doesn't write anymore to burnish (rub and flatten) the areas that you want to recede. Be careful burnishing along the burn lines; if they were cut by a skew tip, they can split open when burnished, which destroys the burned line. Practice with your burnishing tool on a scrap piece of leather before working on your coaster.

Finishing

Leather can be finished using leather polish, leather conditioner, or paste wax. Test your finishing product on a scrap piece before using it on your final project. For this project, I used clear (neutral) leather shoe polish. Rub on the polish/wax in a circular motion using a soft cloth. Buff off the excess polish or wax.

Materials & Tools

MATERIALS:
- Leather, vegetable-tanned, ⅛" (3mm) thick: 3" (76mm)-diameter discs, such as Leather Rounders
- Leather polish, leather conditioner, or paste wax
- Permanent colored markers, such as Sharpie®, and/or acrylic paint

TOOLS:
- Variable temperature wood burner with tips: fine/micro writing, small round-heel skew, medium spoon shader
- Basic pyro kit (see page 101)

The author used these products for the project. Substitute your choice of brands, tools, and materials as desired.

TIP

TESTING THE COLORS

Marker colors change and darken slightly on leather, so test your colors on scrap pieces of leather.

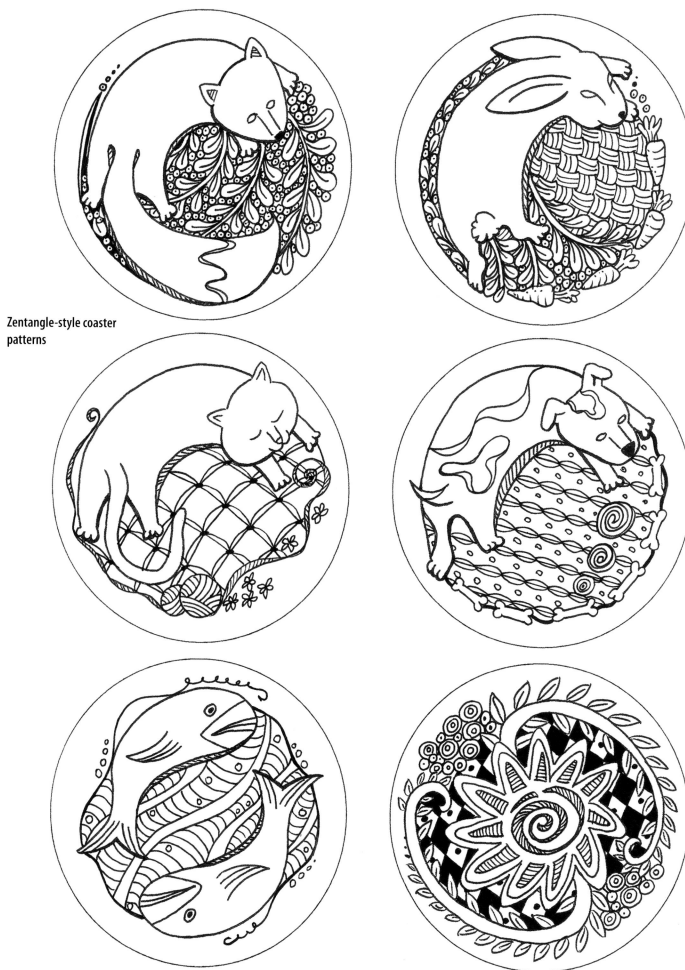

Zentangle-style coaster patterns

Burn a Leather Bookmark

**Practice leather burning techniques
with this quick and easy project**

By Tracey "Scorch" Annison

Pyrography is quite easy. If you have a steady hand and can draw over a tracing with a felt-tip pen, then you can do pyrography. What I like best is to make unusual, meaningful items you simply can't buy in the shops, such as this leather oak leaf bookmark. The oak leaves symbolize strength and endurance while the acorn holds the promise of growth and new life.

You work on leather the same as on wood, but you may need a temperature-controlled pyrography machine because leather burns at a much lower heat than wood. If you are using a solid-point or soldering iron-style machine, you'll need to experiment to see if moving your hand quickly or blowing on the nib helps. If the nib is glowing, spitting, smoking, digging in, or making sizzling noises, it's too hot.

I create different effects by varying the temperature, the time the tip is in contact with the surface, and the method of applying the tip. I usually work with wire tips that I've shaped into flat U-shapes in various sizes.

BOOKMARK: BURNING THE ACORN

1 **Prepare the bookmark.** Buy a leather blank or cut your own. You must use vegetable-tanned leather; chemical-tanned leather is hazardous to burn. Transfer the design to the leather using graphite paper. Insert a 2mm writing tip and test your pyrography machine on scraps to fine-tune the heat.

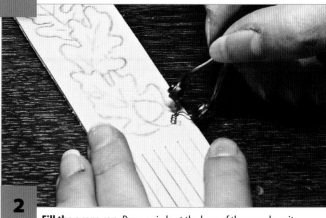

2 **Fill the acorn cap.** Draw a circle at the base of the cap where it meets the stem. Work outward, drawing reversed Cs on the right side of the circle, making each one meet the one before it. Then draw Cs on the left side of the circle. Add additional rows by drawing upside-down Us. Draw the middle U first, and then work outward on each side.

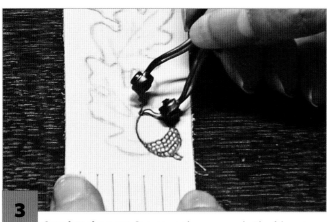

3 **Complete the acorn.** Burn a smooth curve on each side of the nut, joining the lines together in a point. Outline the stem with a couple of little lines. Hold the pen and draw the curves in a way that feels natural and comfortable, repositioning the bookmark as necessary.

BOOKMARK: BURNING THE LEAVES

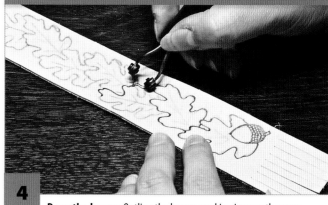

4 **Draw the leaves.** Outline the leaves, working in smooth curves. Start at the bottom near the acorn and work toward the top. If you find the tip catches or sticks as you push it away from you, try pulling it toward you. Outline all of the leaves. Don't worry if the lines on the edges wiggle a little; that is natural for leaves.

BOOKMARK: SHADING AND FINISHING

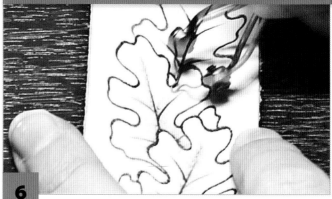

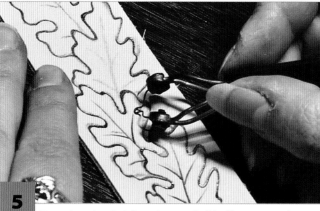

5 **Draw the veins.** Switch to a 3mm tip. Each leaf has one central vein up the middle with smaller veins flaring outward. Draw the lines quickly with the tip held edgeways, sweeping the tip along and off of the leather so the veins fade away at the ends. Erase the pencil lines and sweep the eraser crumbs away; burning the crumbs will ruin your work and the smoke could be hazardous.

6 **Shade the leaves.** Use the wider tip turned broadways and let the heat loss do the work for you. Place the tip flat along the center vein where the darkest part should be and instantly draw it away, pulling along and off of the leather. Don't let the tip stand still at any point. The heat fades away, and so does the color, in a nice broad stripe. Repeat the motion to shade the side veins, blending the shading strokes with each other.

BOOKMARK: SHADING AND FINISHING

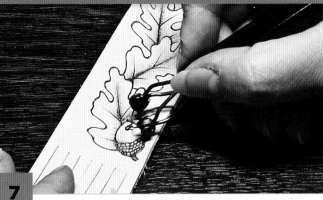

7

Detail the leaves and shade the acorn. Enhance and finish the center vein by drawing directly over it with the tip turned edgeways, the same way you originally drew the line. Use the heat-loss technique to shade the acorn, sweeping upward from the base of the nut. Follow the curve of the nut and leave a little space between the strokes for a striped effect.

8

Protect your work. Finish the bookmark with clear leather polish to protect it against dirt, grease, and water damage. The color of the leather will darken when you apply the polish, but lighten as it dries. Test your polish on a scrap piece of leather first.

TIPS

BURNING AT LOW TEMPERATURES

If you can't lower the heat on your pyrography machine enough to successfully burn leather, ask the manufacturer for help. I bought a half-heat box, which is a special resistor that lowers the heat and gives far more control.

DEPTH OF BURN

Speed controls the depth of burn, not pressure. More pressure will only dig the tip into the surface. Leather is easier to work than wood, requiring no pressure at all.

Bookmark pattern

Materials & Tools

Materials:
- Vegetable-tanned leather bookmark
- Graphite paper and pencils to trace and transfer pattern
- White artist's eraser
- Clear leather polish

Tools:
- Variable heat pyrography machine
- Writing nibs: 2mm, 3mm

The author used these products for the project. Substitute your choice of brands, tools, and materials as desired.

Burning a Classic Leather Mouse Pad

Detailed design decorates this functional project

By Michele Parsons

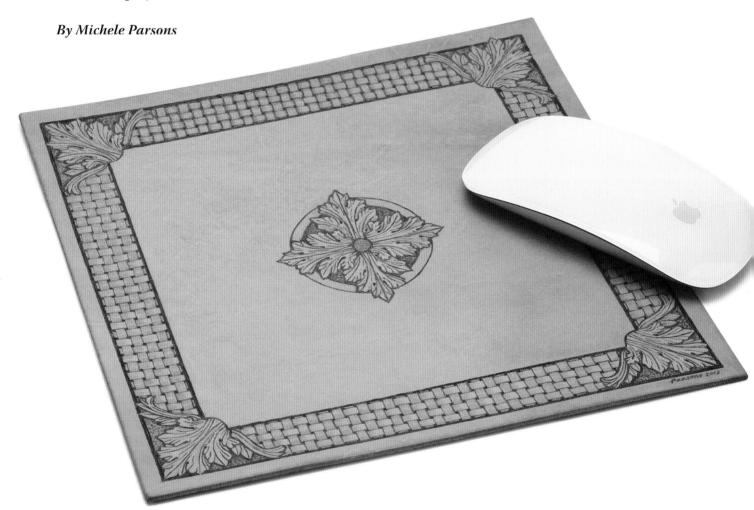

I enjoy burning on leather because the surface is so smooth. Lines are crisp, the shading is smooth, and there is no wood grain to contend with. Leather also has the advantage of being easily embossed, adding a texture and tactile feel to the work.

Always choose vegetable-tanned leather to burn on. It is usually tan, thick, and hard. Chemical-tanned leather (most soft, pliable, and colored leathers) will produce toxic fumes when burned.

The tanning process leaves leather uneven in thickness, so leather is measured and sold in ounces. A leather ounce is equivalent to about 1/64" (.4mm), so an 8 oz. leather piece is about 1/8" (3mm) thick. Leather is sold by the hide, as scrap pieces, or precut and packaged for hobbyists. Leather hides are sold as the complete hide (skin) or cut into sections: bellies, sides, and backs. For this project, I purchased a 2–3 oz. precut rectangle of blemish-free leather.

MOUSE PAD: PREPARING TO BURN

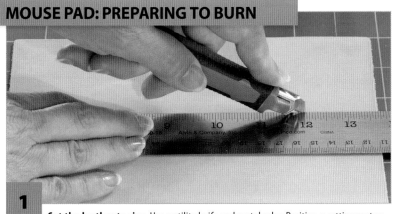

TIP

PROTECT THE LEATHER

Moisture and oil from your hands can soil leather. Use paper or a towel to cover the areas you are not immediately working with, or wear a cotton glove on the hand you use to hold the leather.

1 **Cut the leather to size.** Use a utility knife and metal ruler. Position a cutting mat or thick board under the leather to protect your table. If you use a thick piece of leather, cut it in stages. Make a cut and then fold the leather along the cut until the cut opens up. Do not tear the fibers that are not yet cut. Make a second pass with the knife down the previous cut. Bend the cut open again. Repeat this process until you cut the whole way through.

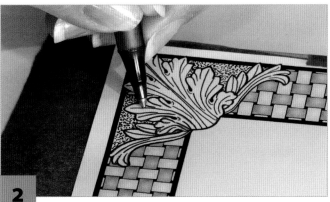

2 **Transfer the pattern to the leather.** Tape the pattern to the leather and use graphite paper to transfer the design (see page 106). Use a ruler for the straight lines. Make sure the transferred image is dark enough to see but light enough to erase. After tracing the design, remove the pattern and use a rubber cement eraser to remove any adhesive residue.

MOUSE PAD: BURNING THE OUTLINES

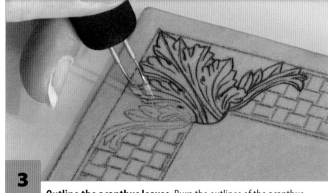

3 **Outline the acanthus leaves.** Burn the outlines of the acanthus leaves at the corners and in the center using a round heel skew tip. Remember that leather burns easily, so start with a lower temperature and/or test the burn on scrap leather to get the settings correct. Use a micro writer tip to burn the "holes" on the acanthus leaf edges.

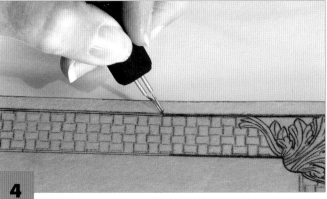

4 **Burn the border.** To form the thick, dark line of the border, burn along each side of the line using a skew tip guided by a metal ruler. Then, use a micro writing tip to fill between the lines. You may need to go back over the filled lines with a skew tip to darken the leather to the outlines you made with the ruler.

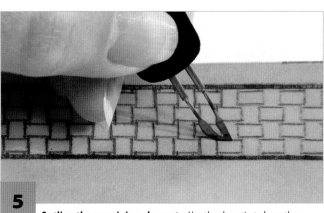

5 **Outline the remaining elements.** Use the skew tip to burn the basket weave pattern inside the border. Then, burn the outline of the center circle. Erase any graphite or pencil lines. Use the edge of a razor blade to gently scrape any edges that need to be smoothed. Too much scraping can mar the leather. Darken and touch up any lines as needed.

MOUSE PAD: SHADING & TEXTURIZING

6 **Add the dark tones.** Darken the points of intersection between the basket weave. Use a micro writing tip to darken along the bottom edges of the acanthus leaves.

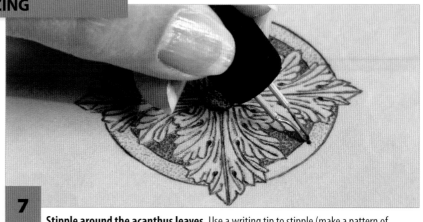

7 **Stipple around the acanthus leaves.** Use a writing tip to stipple (make a pattern of close-together dots) around the acanthus leaves. Stipple darkly inside the interior circle of the central medallion. Lightly stipple around the outer circle by turning down the burner heat and spacing the dots out more. Use the darker stippling around the corner acanthus leaves in the area where there is no basket weave.

8 **Shade the acanthus leaves and basket weave.** Use a shader tip to lightly add shaded tones to the acanthus leaves, following the directional lines on the leaves. Shade the basket weave by shading all the cords on a border side running in the same direction, such as all the horizontal cords. Shade half of each cord segment using a series of wide, light lines that start at the point where each cord is intersecting (going under) the next cord and pulling toward the high point—halfway across the cord segment. Make each stroke start at the line and gradually disappear toward the center by lifting off as you reach the center. Then, turn the project and pull from the opposite direction (intersection line to the high point). Repeat the process for the cords running the other direction, such as the vertical cords. To add a highlight, I picked a direction the light was coming across the mouse pad and left the half shading on all the cords facing that direction unshaded.

MOUSE PAD: FINISHING THE PROJECT

9 **Clean up the project.** Use the edge of a razor blade to scrape any dark splotches in the shading. Sign your name (or initials) and date in pencil in an obscure place, like the outside edge of the border near a corner. Burn over the pencil lines using a micro writing tip.

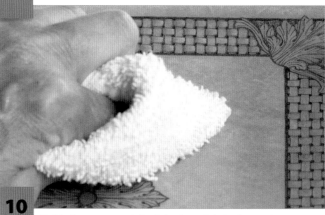

10 **Finish the mouse pad.** Apply leather polish, leather conditioner, or paste wax. Test your finishing product on a scrap piece before using it on your final project. For this project, I used clear (neutral) leather shoe polish. Rub on the polish/wax in a circular motion using a soft cloth. Buff off the excess polish or wax.

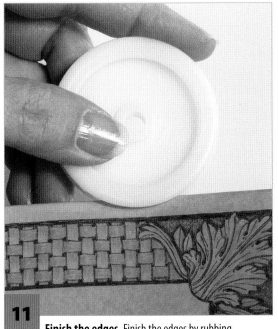

11 **Finish the edges.** Finish the edges by rubbing some of the polish/wax along the side after polishing the top surface. For a smooth finish, you can then use an Edge Slicker (available where you purchase leather supplies). Rub the Edge Slicker back and forth along the polished edge to burnish the leather. You can also finish untreated edges by running a damp sponge along the edge. Avoid rolling the sponge onto the top or touching the top with damp hands, which will stain the leather. After allowing the water to soak into the edge a few minutes, use an Edge Slicker to burnish the edges smooth by rubbing it back and forth along the damp edge.

Materials & Tools

MATERIALS:
- Leather, vegetable-tanned, 2–3 oz. (2mm thick): 8 ½" x 8 ½" (216mm x 216mm)
- Leather polish, leather conditioner, or paste wax

TOOLS:
- Metal ruler
- Utility knife
- Cutting mat

- Variable-temperature woodburner with pens: fine/micro writing, small round heel skew, medium spoon shader
- Single-edge razor blade
- Edge Slicker tool (optional)
- Basic pyro kit (see page 101)

The author used these products for the project. Substitute your choice of brands, tools, and materials as desired.

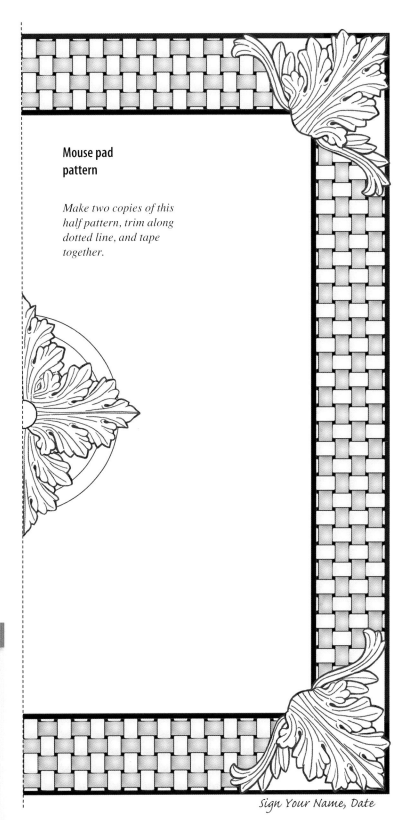

Mouse pad pattern

Make two copies of this half pattern, trim along dotted line, and tape together.

Sign Your Name, Date

TIP

PREVENT WATER SPOTS

If you get water on the leather, quickly wipe the entire surface with a damp (not wet) sponge, which will even the tone to avoid spots.

Quotable Zenspirations®

**Designs to inspire your creativity
and feed your spirit**

Designs by Joanne Fink

Zenspirations® is a combination of practical art techniques and uplifting spiritual philosophy. I created these designs with extra room so you can express yourself by drawing additional elements and patterns, like dots, swirls, and vines. You can burn the designs on almost any medium—watercolor paper, leather, and wood are pictured (clockwise from top left)—and then further customize them by coloring with crayons, colored pencils, markers, watercolors, acrylics, glazes, or dyes. For more designs, please explore my Zenspirations® "Color, Create, Pattern & Play" books, Inspirations, Flowers, and Abstract & Geometric Designs. And for patterning techniques, check out Zenspirations® Letters & Patterning and the Zenspirations® Dangle Design Workbook. I hope they will spark your creativity and inspire you to make the world a little more colorful.

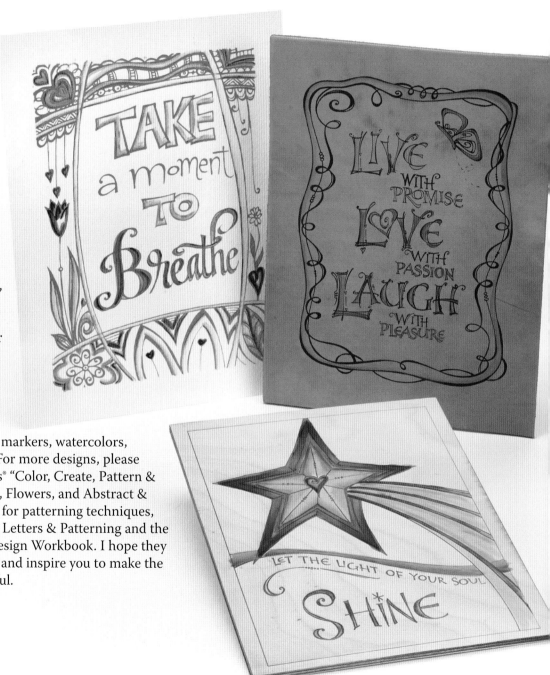

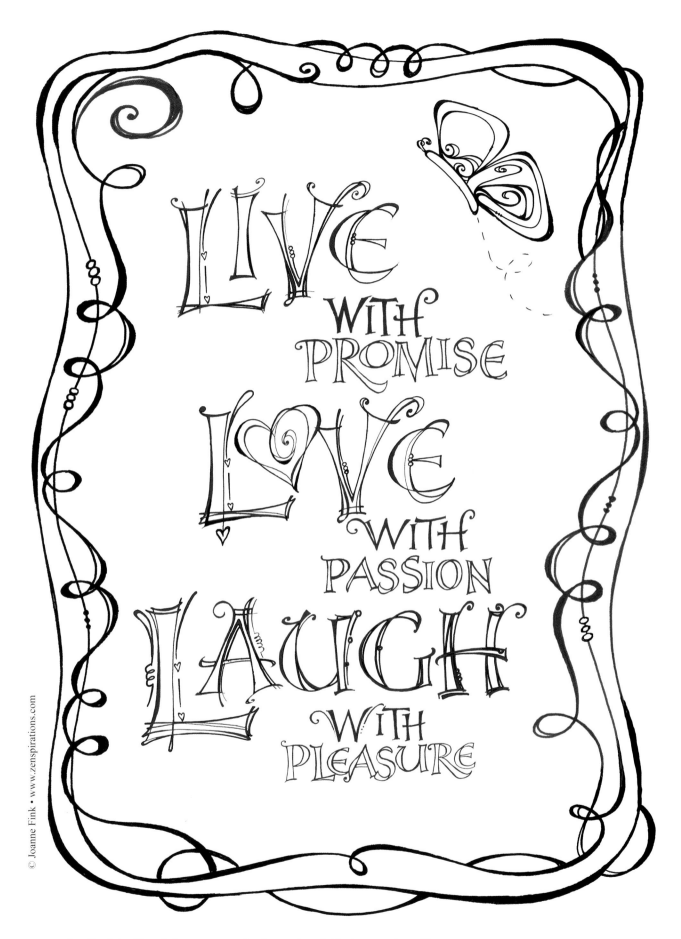

LIVE WITH PROMISE LOVE WITH PASSION LAUGH WITH PLEASURE

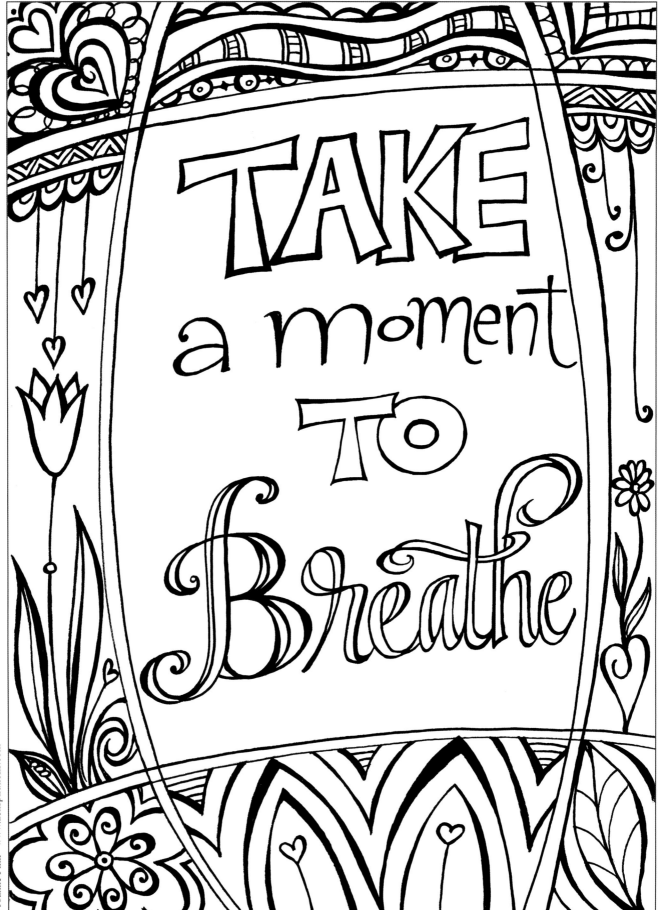

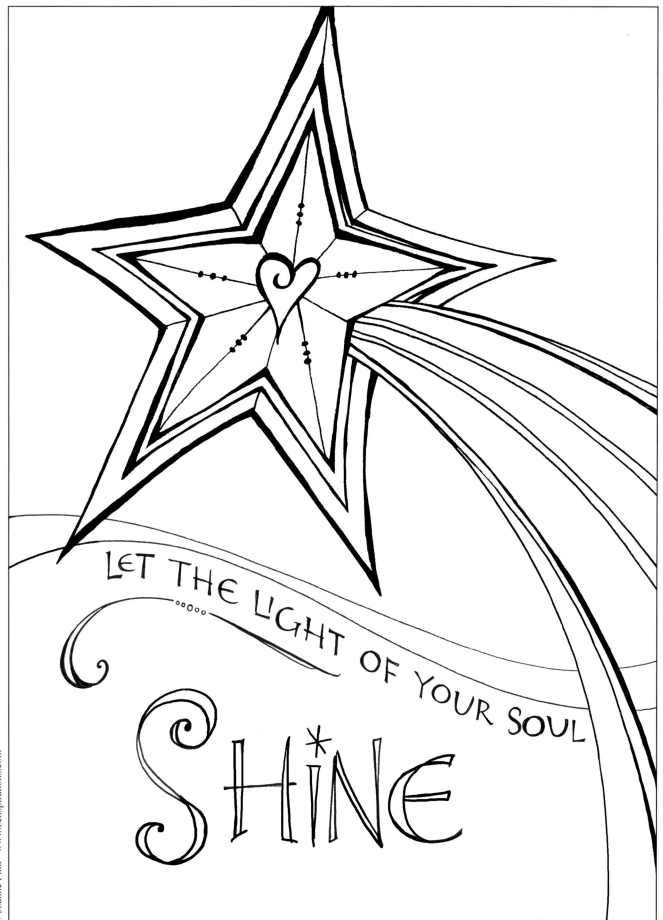

LET THE LIGHT OF YOUR SOUL SHINE

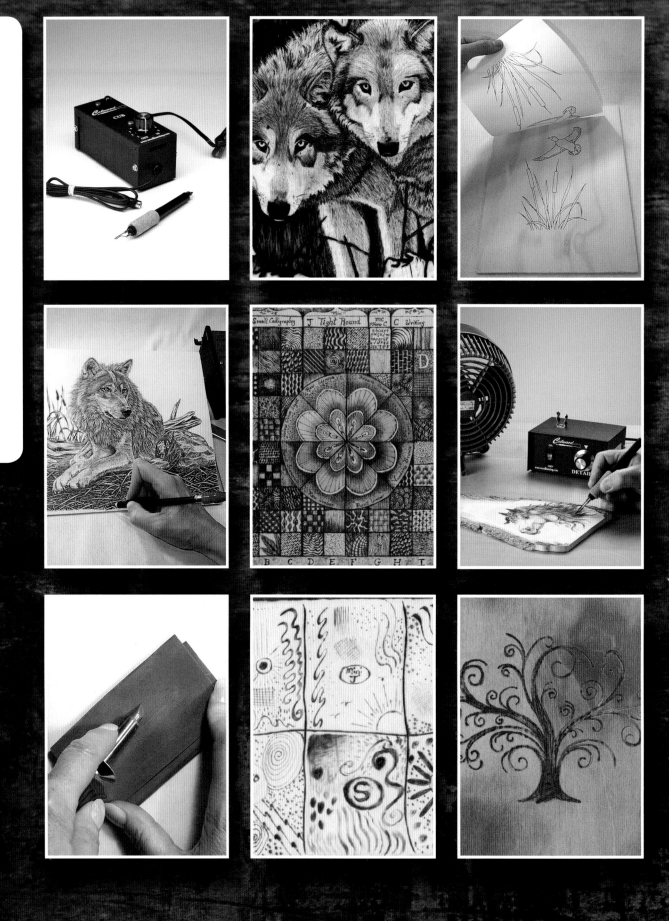

Building a Basic Pyrography Kit

Additional tools and equipment will increase your enjoyment

Compiled from information provided by
Lora S. Irish, Sue Walters, and Simon Easton

While your pyrography machine and material of choice are the most essential items for beginning any pyrography project, some additional equipment is required. They are mostly common household supplies, but it makes sense to gather your tools so they are at hand when you need them. These items will make the woodburning experience easier, more pleasurable, and safer, no matter how large or small the project.

Photo courtesy Simon Easton

Work Area

- Light source: Usually shines from the direction opposite your drawing hand.
- Old sheet of plywood: To place on a workbench as protection from scorches. You can also purchase a heat-resistant mat designed to cope with extremely high temperatures.
- Leaning board to tilt work: As simple as a piece of plywood leaning against some books.
- Tin lid of an old jar or glazed tile: For holding warm nibs.
- Fan: For pulling smoke away from your project.

Patterns, Transfers, and Prep Work

- Sandpaper, sanding block, and/or orbital or belt sander: To prepare the surface of the workpiece.
- Rag or tack cloth: To clean away dust after sanding.
- Graphite paper, vellum, or tracing paper: To transfer a design or pattern.
- Tape: For holding patterns down during transfer.

- Fine red ballpoint pen: For transferring patterns. Red is more easily seen over black pattern lines.
- Scissors: For cutting paper.
- Metal ruler, T-square, and/or a 90° drafting triangle: For drawing straight lines and measuring.
- Compass and/or geometric stencils: Useful for accuracy when working with borders or other geometric shapes.
- #2B pencil or mechanical pencil: Soft enough to erase, for drawing on wood without leaving an impression.
- Pencil sharpener

Burning

- Needle-nose pliers: For removing hot nibs from solid-point and interchangeable-wire burners. For variable-temperature tools, a small screwdriver will do the job.
- Nib-cleaning materials: Fine sandpaper; a leather strop and aluminum-oxide honing compound; emery cloths or steel wool, and an old craft knife blade.

- Sharp blade: For picking out highlights, erasing mistakes, cutting patterns, sharpening nibs, and cleaning stubborn carbon from nibs.
- Scrap material: For practicing strokes and testing the temperature. Use the same material as the main project.

Finishing

- Fine-grit sandpaper and foam-core emery boards: To sand lightly after completing the burning.
- White artist's eraser: To erase lines after burning. Avoid colored erasers, because they can leave permanent streaks on the wood that require sanding for removal.
- Varnish, oil, and/or wax: Spray or brush on, to protect your work after completion.

Coloring Equipment (optional)

- Artist-quality colored pencils: Available in three styles: dry (chalk), oil, and watercolor. Avoid student-grade pencils, which will not work well with your woodburning.
- Artist-quality watercolors: In either tube or cake form. Very transparent and most often used on soft woods such as basswood and pine.
- Oil paints: Used for harder woods, such as birch, maple, or walnut; easily blended for new colors.
- Soft sable brushes: Used to apply paints.
- Glazed tile or plate: Palette for mixing paints.
- Turpentine and linseed oil: For mixing and cleaning up oil paints.

Pyrography chart courtesy of Sue Walters

Top Beginner's Woodburners

These entry-level models get you burning without breaking the bank

By Bob Duncan

Like most tools, woodburners are available with a variety of extra features. From digital temperature controls and two-pen systems, to micro-adjustable temperature controls and combination burner/micro motor units, each manufacturer offers different options. But most beginners just need a basic unit until they decide what type of burning to do. If possible, try several units to see which you prefer.

Single Temperature vs. Variable Temperature
While many inexpensive soldering-iron style burners are available, the tip size and shape and single temperature setting make them more difficult to use. I suggest that most beginning pyrographers choose a variable-temperature burner because they are easier to control and provide a greater selection of tip shapes.

A Word on Tips
Most manufacturers design burning pens and tips specifically for their units. Each manufacturer also makes a few tip shapes that are different from other manufacturers. The good news is that most manufacturers have conversion kits that allow you to use different manufacturers' pens with their burner units.

Pens come in two styles: fixed tip and interchangeable tip. In the fixed tip style, each pen comes with a different tip, so you change pens to change tips. With the other style, you have one pen and change just the tip. Some artists like the versatility of the interchangeable tips, which allow you to get a variety of tips for a small investment. But other pyrographers feel the connectors that allow you to change the tips are difficult to use, or that they are unreliable and bleed off power. If possible, try both styles of pen to see which you prefer.

The Burners

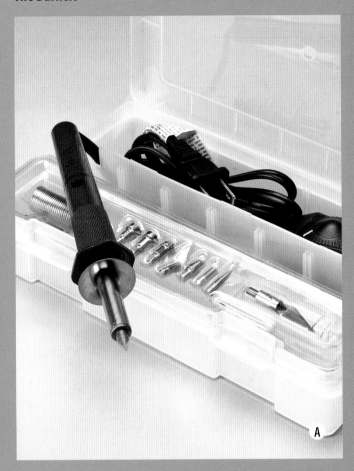

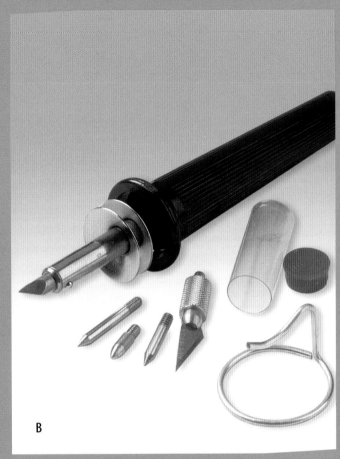

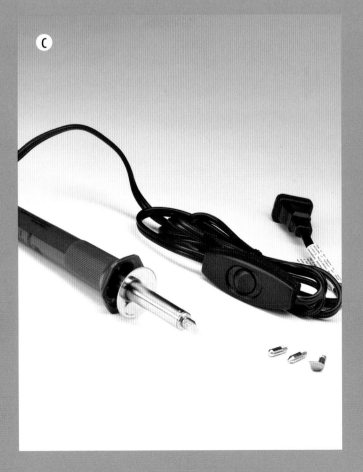

A. Walnut Hollow Creative Versa-Tool

This inexpensive variable-temperature woodburner is made in the soldering-iron style, but has a rheostat on the cord to control the temperature. People with small hands may find the thick unit difficult to hold and control. Comes with 11 different screw-on tips.

800-437-3635; www.WalnutHollow.com

B. Dremel 1550 VersaTip Multipurpose Woodburner

The Dremel 1550 Versatip Multipurpose Woodburner is a single temperature woodburner with five interchangeable tips. However, this woodburner can accommodate any screw-type tip. While a single temperature woodburner takes time to heat up, the Dremel holds its temperature well. It heats up to 1,050° F so you can burn quickly and safely. It comes with a tool stand and tip storage.

800-437-3635; www.Dremel.com

C. Walnut Hollow 5570 Creative Value Burner

This is the perfect woodburner for beginners. It's the least expensive burner on the market, so you can begin burning without a heavy investment. The Creative Beginner comes with four tip shapes—cone, shading, universal, and flow—and is a single-temperature burner.

800-437-3635; www.WalnutHollow.com

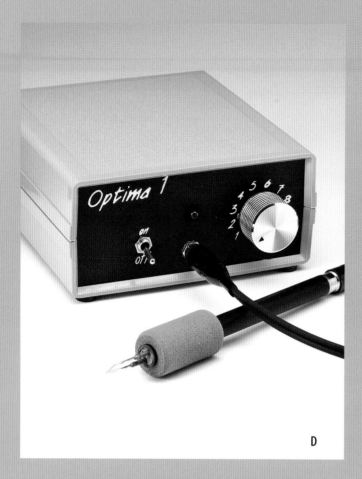

D

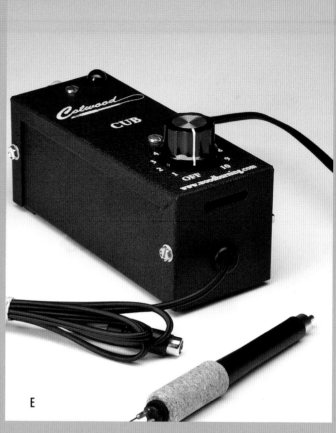

E

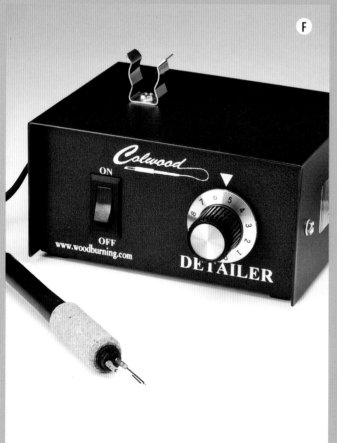

F

D. Optima 1 Single

The Optima 1 comes with an extremely flexible pen cord for use with their standard fixed-tip pen. A heavy-duty cord is available for use with heavy-duty pens and tips. The jack for the pen cord is on the front of the unit, and it has a snap-in pen holder on the top. Your choice of fixed-tip pen is included.
320-594-2811; www.CarverTools.com

E. Colwood Cub

The least expensive hot-wire variable-temperature woodburner, this compact unit accommodates any Colwood pen (sold separately). While it lacks a pen holder, it includes a cable clamp so you can hang the unit over the work area. The pen cord attaches internally. The on/off switch is integrated into the temperature-control dial.
732-938-5556; www.Woodburning.com

F. Colwood Detailer

The first unit Colwood created is still the company's biggest seller. It features a temperature-control dial and lighted on/off switch. The pen cord attaches to the back of the control unit with two screws and can be replaced. The unit accommodates any Colwood pen (sold separately), and includes a snap-in pen holder on the top.
732-938-5556; www.Woodburning.com

G

H

I

G. Razertip SK

The SK is safety certified in both the United States and Canada, and features a pen cord jack in the front. The unit can handle all of Razertip's standard and heavy-duty pens, and has a snap-in pen holder on the side. Comes with a cord and pen.

306-931-0889; www.Razertip.com

H. Detail Master 8421 Dagger

The Dagger allows you to use most of Detail Master's standard, vented, or replaceable-tip pens (sold separately) and includes a scabbard-type pen holder. It has a large dial and on/off switch, and a jack port on the front of the unit.

708-452-5400; www.DetailMasterOnline.com

I. Burnmaster Hawk

The Hawk comes with the cords and adapters to use any pen via the jack on the front of the unit, but does not come with a pen. The Burnmaster pen (available separately) accepts any Burnmaster tip and will accommodate replaceable tips from Detail Master, Colwood, or Razertip. The Burnmaster pen can be used with any burner control unit.

800-284-6229; www.WoodCarversSupply.com

Before You Burn

Good preparation is the foundation of great results

By Sue Walters

Although you're eager to get started, taking the time to properly prepare your wood and transfer your design will help you produce consistent pyrographic results. Let's look at various ways to prepare a wood surface and transfer a design to your project. Experiment with the different methods before settling on a technique.

Preparing the Wood

The wood for pyrography work needs to be sanded fine so the nib can travel smoothly across the surface at a consistent speed with as little resistance as possible.

Sanding by hand is the cheapest method, but not always the easiest. For larger projects or to do several pieces, I use an inverted belt sander or a random orbital sander. These machines require an initial investment, but if the wood needs a fair bit of work, they can cut down on effort and save time.

An inverted belt sander, known as a linisher, is a slow-moving bench-mounted belt sander, and it's ideal for straight-edged projects. It's also perfect for sanding small objects, like refrigerator magnets and key ring blanks—objects where it is easier to place the blank on the sander, rather than the sander on the blank. (This also applies to hand-sanding small objects.)

A random orbital sander is easy to use and won't run away from the work or damage the wood like a disc sander can. Flat orbital, mouse, and palm sanders will also do a decent job. A little hand sanding with 400- to 600-grit (extra fine) sandpaper is sometimes necessary if you want a super-fine finish or need to eliminate any swirl marks after machine sanding.

For small projects, I hand-sand with either a sanding block or a sanding pad. Sanding blocks are more suitable for flat surfaces and can be as simple as a block of wood, cork, or rubber with sandpaper wrapped around it. To make life easier, hardware stores sell foam blocks that are impregnated with abrasive material. Sanding pads are more flexible and are excellent for sanding round objects or small areas.

Once you've finished sanding, wipe the surface with an old rag or tack cloth and then transfer the design.

Placing the Design

When placing the design, orient it to suit the shape and grain of the wood. If your design is landscape-oriented (horizontal), lay the pattern on the wood so the grain runs horizontally across the picture. Then, incorporate the grain or figure of the wood into the picture. For instance, the grain might accentuate items like clouds, water, the ground, or stripes on a zebra.

You can use faults in the wood to help the piece rather than hinder it. Turn a knot in the wood into a depression in a tree or a fallen log. Use spalting, a fungal discoloration of the wood, to indicate an evening sky or an angry sea.

Because wood can burn differently depending on its density, avoid placing the main subject of your drawing halfway across two different parts of the wood. For example, if you are burning a picture of a horse and you have half of it over a hard patch of grain and half over a soft patch, you will end up with two distinctly different-looking halves of a horse.

Transferring the Design

Carefully transferring the design will give you a clear map to follow when you begin burning. The following methods outline some of the ways this can be done

Tracing:

Never use carbon paper to transfer your pattern or design. Lines traced with carbon paper can bleed on contact with heat and are difficult, if not impossible, to erase. Black graphite paper won't bleed and can be erased or sanded to lighten an area that has transferred too darkly. Use a #2B pencil to darken any lines that are too faint. Graphite paper also comes in white, which is handy if you want to trace a design on dark or pre-burnt wood.

Use graphite paper to trace the design and transfer the pattern to the blank.

1) Place the pattern face up on the blank.

2) Tape the pattern in position.

3) Place graphite paper between the pattern and the blank.

4) Test to make sure the graphite paper is right side down.

5) Trace the pattern with a #2H pencil or a red ballpoint pen.

6) Lightly sand the design if the transferred image is too dark. If it is too light, darken the pattern lines with a #2B pencil.

Heat Transfer:

If a pattern is made with a laser printer or photocopier, you can place it face down and apply heat to the back to transfer the pattern to the surface underneath. However, the image will be the reverse of the original. If you want the image to be an exact copy of the original, you must flip the image on your computer or on a photocopy machine before printing it.

A shading nib turned up quite high and rubbed along the lines of the pattern gives

Use heat to transfer the toner of a photocopied pattern to your pyrography blank.

an extremely crisp transfer. A clothes iron (without the steam) can also be used, but I've found that the toe of the iron, not just the base, needs to be rubbed firmly over the pattern to prevent a patchy transfer. Freshly printed paper works best. Lightly sand off excess darkness after the transfer, leaving just a faint pattern.

1) Place the pattern face down on the blank.

2) Tape the pattern in position.

3) Use a shading nib or a clothes iron to heat the back of the pattern.

4) Sand lightly if the image appears too dark. Faint lines are preferable to dark lines because they won't show in the finished project.

Spirit Transfer:

You can also transfer laser-printed or photocopied images by placing them face down and rubbing mineral spirits on the back. The spirits dissolve the toner, which transfers to the surface underneath. The image will be reversed; if you want an exact copy of the original, flip the image on your computer or on a photocopy machine before printing and transferring it.

The spirit transfer method is faster than the heat transfer method, but a little messier. I have also found that the image isn't as crisp, and it tends to bleed if you are heavy-handed with the rubbing. When you are done transferring, let the spirits evaporate and then lightly sand the pattern so only a light image remains before you burn.

Use mineral spirits to transfer a photocopied or laser-printed pattern to your blank.

1) Place the pattern face down on the blank.

2) Tape the pattern in place.

3) Use a brush, your fingers, or a cotton ball to moisten the paper with mineral spirits.

4) Push down to transfer the pattern.

5) Peel the paper away and allow the wood to dry thoroughly.

6) Lightly sand if the image has transferred too darkly.

Play It Safe

**Avoid harming yourself and others
by observing these safety tips**

By Sue Walters

In addition to heat and fire safety, there are a few concerns you should be aware of before you begin your first pyrography project. Use common sense and follow these guidelines to keep yourself safe as you learn to burn.

Smoke

Many pyrographic techniques create little or no smoke, but sometimes you will see it, especially when the nib heat is set on high. A dust collection or ventilation system is best to extract smoke, but the average hobbyist usually will not have access to one. There are several ways to prevent inhaling smoke.
- Work in a well-ventilated room.
- Use a fan, pointed away from your work, to suck the smoke away. The air from a fan pointed at your work can affect the nib temperature, resulting in inconsistent burning. The same can happen with a draft from a window.
- Make sure your head stays far back from your work. Tilt your work by placing it on a sloped surface so you can keep your head back and still see your work.
- You can use your breath to gently blow away a stream of smoke as long as you don't blow directly on the nib.
- Masks and smoke filtration systems are another option; however, smoke particles are extremely small and the average filter will not trap them. Only masks and filtration systems rated to capture smoke will be adequate. A dust mask is not sufficient. Please check with a specialist for further advice.

Fire and Burns

By definition, you are burning the work surface when you create pyrography. Although the nibs get very hot, some common sense will prevent harm to you and your surroundings.
- Always turn your burner off when you're not working. It's easy to get distracted and forget it's still on.
- Place your project on a slope to keep your hand angled away from rising heat.
- If you have a solid-point set-temperature burner, be aware that the heating element can get extremely hot and keep your hand well away from this area.
- Never burn near water.
- Always turn off the iron to change nibs.
- When resting the burning pen, use the holder provided. Secure the holder by taping or clamping it to your workbench.
- Don't leave children unattended around a pyrography machine—ever.
- If the cord or handle of your burner gets hot and you are getting little or no heat to the nib, turn off the unit and check all of the connections to see if they are firmly plugged or screwed in. If the problem persists (and especially if there is a buzzing noise), contact the manufacturer for advice before further use.

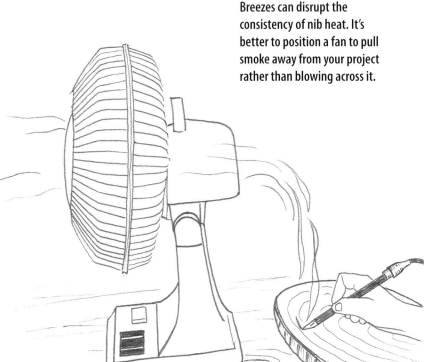

Breezes can disrupt the consistency of nib heat. It's better to position a fan to pull smoke away from your project rather than blowing across it.

Health Concerns

At times you might be tempted to burn materials other than wood. Before you do, question your choice. If it isn't a natural product, think twice. When in doubt, ask the manufacturer for a Material Safety Data Sheet (MSDS) or conduct an Internet search. Concern for your health should always be foremost.

- Even though hot-cutting polystyrene is a recommended side use for some burning units, I do not recommend it. This material contains some chemicals that I believe could be hazardous to your immediate and long-term health.
- Be wary of acrylic resin (the plastic-type sheeting that looks like glass). Some pyrographers advocate burning this material, but I strongly urge caution.
- Never use treated or sealed wood for pyrography. Burning treated wood can produce toxic fumes. This includes wood treated with a sanding sealer.
- Never use medium-density fiberboard (MDF), man-made boards, or other bonded material for pyrography. They can be made of toxic materials and the fumes, if inhaled, can cause serious health problems.
- Natural cork can be used, but be careful of cork sheeting, as it can sometimes contain a resinous binder to improve the durability.

- If you burn plywood, be careful not to burn deeply into the glue layer.
- Always wear a dust mask when sanding.
- Leather and animal hides are wonderful to work on, but use only vegetable-tanned leather. Chromium-tanned leather can produce dangerous fumes. (Chromium leather can appear more soft and supple.)
- Some heavy sapwoods, such as cedar, cause irritation to a small percentage of people. If you burn on a wood that disagrees with you, discontinue using it.
- Some techniques encourage the pyrographer to burn on top of pigments. It is still unknown if there is general danger in this practice, so take care in choosing the types of pigments to burn over. Avoid paints and pigments that contain lead and other metals such as cadmium, as well as any that contain arsenic and other chemicals. Ask the manufacturer or your art supplier if you are unsure.

Pattern Making Made Easy

Use your computer to turn a photo into a pattern

By Danette Smith

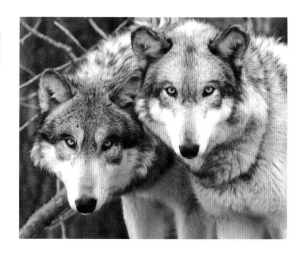

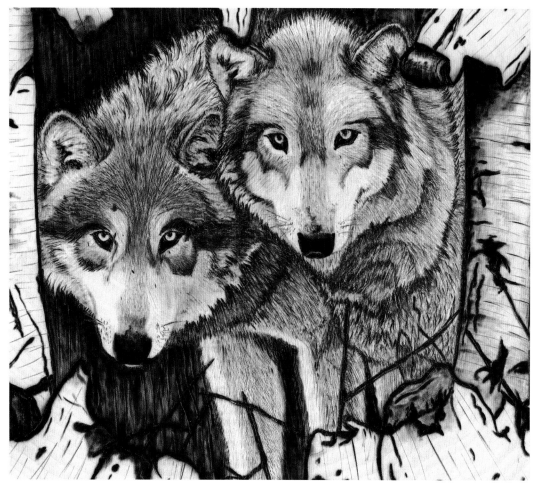

Danette Smith received permission from the photographer and then used computer software to turn this photo (above) into a pyrography pattern (left). Photo courtesy of Monty Sloan, www.wolfpark.org.

You don't need to be an artist to do pyrography, nor do you have to rely on commercial patterns for ideas. Many pyrographers make patterns from photos—their own or licensed commercial images. (If you download photos from the Internet or copy them from books, magazines, calendars, etc., you need to get written permission from the photographer before using them.)

I have admired wolves since I was a child—I find their eyes captivating—so I decided to do a burning of them. I found a photo I liked and requested permission to use it as a pattern from the photographer, Monty Sloan at Wolf Park, in Battle Ground, Ind. Once I had his written permission, I downloaded the photo. In the following demonstration, I'll show you how to turn a photograph into a pattern using your computer, a scanner or digital camera, and photo-editing software. Although these instructions are specific to my editing software, you should be able to do the same steps using most programs. Remember to save frequently during your photo editing session.

Δ Step 1: Scan the photo. Using your scanner software, scan the photo and save it to your hard drive. Choose a resolution between 300 and 600 dots per inch (DPI) and save the file as a TIFF or JPG. TIFF files are larger and more detailed, so choose that setting if possible. If you downloaded the photo or snapped a digital image, use the original digital file, not a printed and scanned copy.

Step 2: Open or download photo-editing software. You may already own photo-editing software, such as Adobe Photoshop, Paint Shop Pro, or Adobe Photoshop Elements. I use a program called Gimp, which is similar to Photoshop but free. If you don't own photo-editing software, download Gimp at www.gimp.org and follow the website's instructions to install it on your computer. (Where Photoshop instructions differ from Gimp, I have added them in parentheses.)

Δ Step 3: Open the photo file. Locate the digital photo on your hard drive and open it inside the editor. I do this by going to the top left corner and clicking on *File*, then *Open*, and choosing the folder and photo from the lists.

Δ Step 4: Copy the photo. Because you don't want to make permanent changes to the original photo, make a working copy before you do anything else. On the top task bar, click on *Image* and then *Duplicate*. The duplicate that pops up has parentheses at the top: (RGB, 1 layer). Close the original photo and then expand the duplicate photo by clicking the Maximize button at the top right corner next to the red X.

Δ Step 5: Turn the photo to black and white. Changing the color image to black and white, or gray scale, helps show the tonal values—the degrees of lightness or darkness. Tone varies from the bright white of a light source (the highlights) through several shades of gray, called mid tones, to the deepest black shadows. The most important design elements of a burning are its tonal values.

Click on *Colors* and then *Desaturate* to remove all of the color information from the photo, leaving only the tonal values. Gimp lets me choose levels of gray based on *Lightness*, *Luminosity*, and *Average*. I chose *Lightness* to get more tonal values for shading without ruining the highlights. (In Photoshop, click *Image, Adjustments*, and *Black & White*, and then experiment with presets such as *Darker* and *Maximum Black*.)

Use image-editing software to convert your photo to black and white and then identify the tonal values that you will burn.

Δ Step 6: Simplify the image. I want to establish five tonal levels, or shades of gray. I do this by clicking on *Color*, and then clicking on *Posterize* and increasing the level. *Posterize* shows shapes of light and dark, which will help me see where to shade. (Photoshop: Click *Image, Adjustments*, and *Posterize*, and then slide the lever.)

Δ Step 7: Identify the tonal values. Print the photo or work from the screen and identify the tonal values, or shades of gray, in your image. It might be helpful to number the values: 1 is the brightest value (white), 2 is light gray, 3 is the mid-tone, 4 is slightly darker, and 5 is the darkest value (black). If you think the pattern needs more tones, experiment with the *Posterize* settings. You can also adjust the contrast to lighten or darken the tones—click *Colors* and *Brightness-Contrast*, and then slide the lever to adjust. (In Photoshop, click *Image, Adjustments*, and *Brightness/Contrast*, and then slide the lever.)

When you are satisfied with your pattern, save the final version and print two black-and-white copies: label one with the tonal values for reference and use the second as your pattern.

I also make patterns by using software to create pencil line sketches. You can use this method in conjunction with the tonal values method to create outlines that are easy to transfer. Use your tonal-values pattern as a guide to shading while you burn the image.

Step 1: Download sketch software. I create sketches using a free photo-editing software program called Photo to Sketch. You can download the software at www.thinkersoftware.com. Follow the instructions to install the program. Mac users can check the App Store for PhotoSketcher (OS X) or Photo to Sketch (iPod, iPad, iPhone).

Δ Step 3: Convert the image. Set the sketch tab to *Pencil*, the *Precision* to 11, and the *Line* to 5. You can also experiment with the settings to find the look that works best for you. Click *Convert*.

Step 4: Save and print the pattern. Use the sketch pattern in conjunction with the tonal-values pattern to create a new burning.

Δ Step 2: Open the software. With the software running, click on the *Open* button, locate your photo, and click to open it.

Use fine-grade sandpaper or emery cloth to keep a soldering iron-type tool's solid brass tip bright and clean. The paper used here is 400-grit emery cloth.

Use a honing board or leather honing strop with an aluminum-oxide compound to clean variable-temperature wire tips and the solid brass tips of the one-temperature tool.

Some variable-temperature tool units include a wire-tip tool scraper for cleaning.

Keeping It Clean

Easy methods to keep your tool tips clean

By Lora S. Irish

As you work with any woodburning tool, carbon deposits will build up on the tip. The hotter the temperature, the quicker the deposits will develop. This black buildup can be transferred to your work, causing dark gray or black streaks that cannot be removed. Heavy carbon deposits can also affect the temperature of the tool tip, causing the tip to cool below its normal heat setting. Unevenly burned lines that vary sharply in color or width are most often caused by a dirty tip.

Check your tool tip often and clean it whenever this buildup becomes noticeable. When the tool tip starts to take on a chocolate-brown tone, unplug the tool. Allow the tool to cool for about 10 minutes. Then, use one of the following three methods to clean your tool tip. Do not attempt to clean hot tips, whether solid brass or wire, because this can damage the metal and the cleaning surface.

Sandpaper

Use fine-grit sandpaper to polish the brass tip of a soldering iron-type pen back to a bright shiny finish. Use either a small sheet of 220- to 240-grit sandpaper or a foam-core emery board for this task. Once you have removed the carbon, add an extra-fine polish to the face of the brass tip using silicon-carbide cloth (emery cloth), which is available in very fine grits of 400 and higher. This method will not work for wire tips because they are too delicate to withstand sandpaper cleaning.

Honing Strop

Using a honing strop and aluminum-oxide honing compound is the second way to clean tool tips, and it works for both one-temperature and variable-temperature tips. Place a small amount of the compound on the strop, and then pull the tool tip across the strop's surface to clear the tip of carbon. This is my favorite cleaning method because it does the least amount of damage to tool tips while restoring them to the bright finish that creates clean burned strokes.

Scraping Tool

The third method can be used with variable-temperature tools. Some manufacturers create a scraping tool that they package with their variable-temperature woodburner. This scraping tool has a sharp metal edge that you can drag the wire tip over to clean off the carbon.

Making Patterns from Multiple Photos

Combine images to create unique artwork and imaginary landscapes

By Doris Lindsey

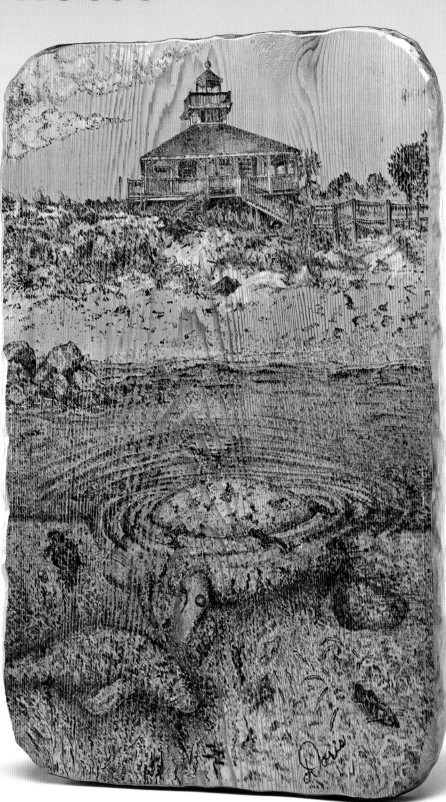

Several years ago, I visited Englewood, Fla. While I was there, a friend took me to Gasparilla Island State Park to see the Port Boca Grande lighthouse. Another time, I visited Crystal River, Fla., and snorkeled with manatees. I used photos from the two trips to create my own ideal landscape. It's a simple process and helps me create unique art that's meaningful to me.

I start by collecting photos that might work well together, such as my lighthouse and manatee photos, and envisioning different ways to combine them. Rearrange the photos and imagine the scene. Don't worry about getting it exactly right—my patterns evolve as I go. Even after I burn parts of it, I might add a bird, sand dune, or rock that was not in the original plan. Don't be afraid to alter your picture or plan to match the vision in your mind.

TIP

ABOUT PHOTO COPYRIGHTS

Use your own photographs to make patterns or get written permission from the photographer. Do not download photos from the Internet; you will be infringing on the photographer's copyright, even if you change or combine the photos in a pattern.

1 **Block out the pattern.** I sketch directly on the blank. You can draw on paper until you master the technique, or if you want to preserve the pattern. I allowed about 6" (152mm) at the bottom for the foreground, where the manatees will be under water. I left 2" to 3" (51mm to 76mm) above that for the above-water area. Next comes a section for the beach and dunes, and finally, at the top, there is a 5" (127mm) section for the lighthouse. Experiment with the proportions that work for your photos, remembering that things at the bottom will appear closer and should be larger, and things at the top will appear farther away and should be smaller.

2 **Photocopy the photos.** If desired, enlarge or reduce the photos. Draw a grid on the copies. Using a grid is the quickest and most accurate way to duplicate photo details. I recommend this technique for buildings and creatures, because those details need to be exact. You can sketch in things like the sky, beach, and water later.

3 **Transfer the main image.** Draw a grid on the pattern or blank with the same number of boxes as you drew on the photos. Change the scale of the image by drawing the boxes larger or smaller than the boxes on the photos. Draw the image from the photo onto the pattern box by box. The grids will help you keep the proportions intact, even if you enlarge or reduce the image during the transfer.

4 **Transfer the details.** You can leave out some details or sketch them in a different place to make the pattern match your vision. Draw grids and sketch the other main elements of the scene, such as the manatees. Then, add light sketches for the rest of the details you want to add to the pattern—clouds, grass, etc. If you are drawing on the blank, keep the lines light because you will erase them later.

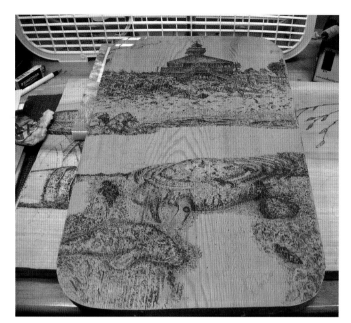

Use a fan to pull the fumes away from you as you burn.

Use a grinder and sanding disc to create contoured edges.

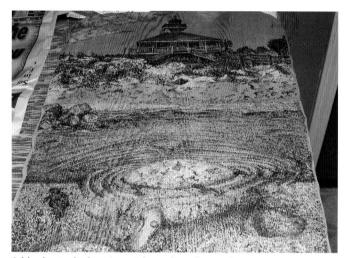

Add color to the burning with acrylic paint washes.

Burning and Finishing the Project

If you drew the pattern on paper, transfer it to the blank. I use medium to medium-high heat for most of my work. To avoid fumes—I'm told red cedar produces some of the worst—I sit in front of a window and use a box fan to pull the fumes away. I wear a respirator for added protection.

I tend to burn slowly, using a lot of stippling (tiny dots placed close together). I do the main images first, such as the lighthouse and the two manatees. Then, I fill in some secondary items, like the fence and trees. Finally, I complete the details and evaluate to see if anything is missing or needs adjustment. I added a fish, some rocks, and underwater grasses that weren't on the pattern. Erase any remaining pencil lines.

When I'm done burning, I like to finish the sides with a grinder and sanding disc. I use a wiggling motion to give the sides a contoured look while smoothing at the same time. I also use the grinder to smooth and finish the rough back.

To add muted color, I mix acrylic and water to create paint washes. I like to keep the paint thin and light, leaving some areas natural. I use white to accent the beach and clouds, and to add some highlights. I accent the lighthouse with white and brown, use green and yellow for the water, and put gray on the manatees.

Finally, after letting the paint dry thoroughly, I brush on three coats of Minwax Polycrylic Clear Satin to seal the finish. Before you open the polycrylic, slowly turn the can over several times—do not shake it. Then, open the can and stir it slowly to finish mixing. If you don't mix it well, you will not get a satin finish.

Materials & Tools

Materials:
- Red cedar: 11" x 17¼" (279mm x 438mm)
- Photographs: several with the same theme, that you took
- Pencil
- Eraser
- Paper (pattern; optional)
- Pattern transfer materials (optional)
- Acrylic paint: white, brown, green, yellow, gray
- Clear finish, such as Minwax Polycrylic Clear Satin

Tools:
- Photocopier
- Ruler
- Pyrography machine and tips: needlepoint
- Small paintbrush
- Grinder and sanding disc (optional)

The author used these products for the project. Substitute your choice of brands, tools, and materials as desired.

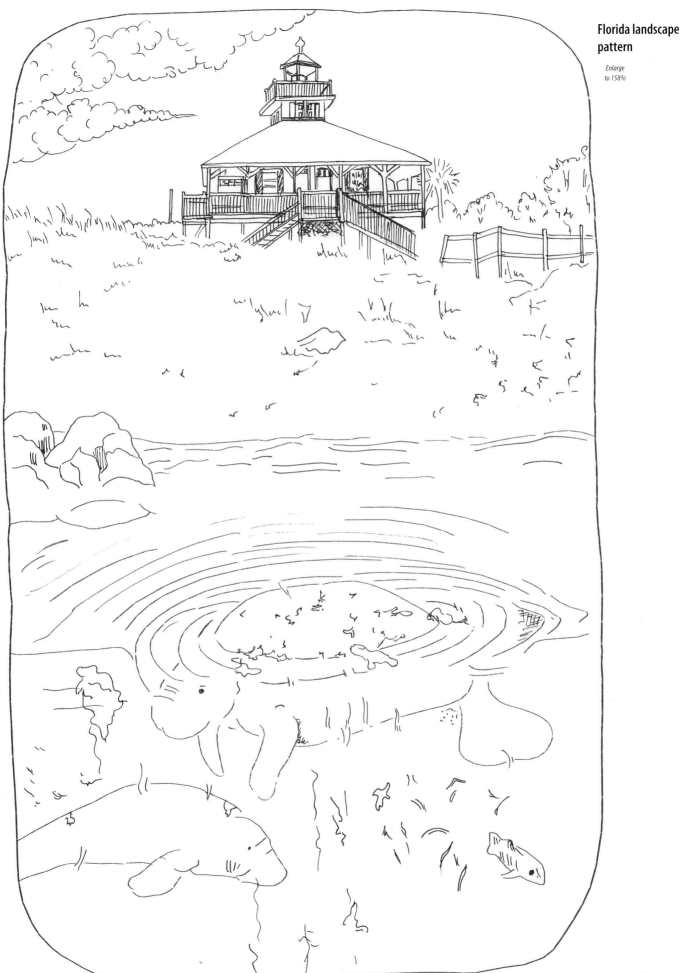

Making Pyro Patterns
(the Easy Way)

**Hint: You don't have to be an artist
or a Photoshop whiz!**

By Chris Wallace for Walnut Hollow

A lot of people think they can't design
their own woodburning projects because
they don't know how to draw or are
uncomfortable using computer software.
I have found two easy ways to design fun
new projects without drawing a thing:
stencils and stamps. Head out to a local
craft store and check out their supplies,
and then mix and match your finds to
create your own unique projects.

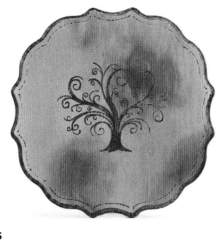

Stencils

Stencils are a terrific source for both the woodburned design and to add color to the blank. Simply find a stencil you like, trace it with a pencil onto the wood blank, and start burning. You can also use a soft sponge and stamping ink to stencil a background design onto the wood, either before or after burning the main image. Stamping inks like Tim Holtz® Distress Inks or Distress Stains from Ranger® are safe to burn over.

Stamps

For more detailed images, try rubber stamps, which come in a huge variety of designs. All you have to do is stamp the image onto the surface and then burn over it. (Make sure you use stamping ink so you do not create fumes when you burn.) You can either stamp the image at actual size or change the size on a photocopier and then transfer the print to the blank (see page 106 for several methods).

I layered stencils by first using them with ink and then burning complementary shapes over the color. Stencil from StencilGirl Products by Mary Beth Shaw.

I colored the blank with ink before stamping and burning the design.

Here I simply colored the wood with safe stamping ink before tracing and burning a stencil design. I used letter stamps (similar to brands) to create the message. Stencil from StencilGirl Products by Mary Beth Shaw.

To change the size of a stamp, stamp it onto copy paper and enlarge the image using a copy machine. Then, transfer the image to the blank for burning.

Materials & Tools

MATERIALS:
- Wood blanks in assorted sizes
- Stamping ink, such as Tim Holtz® Distress Inks or Distress Stains from Ranger®
- Pencil
- Sponge

TOOLS:
- Creative Versa-Tool® and assorted tips, including Hot Stamps Alphabet Set
- Stamps
- Stencils

The author used these products for the project. Substitute your choice of brands, tools, and materials as desired.

Crazy Quilt Sampler

Learn about tips and textures by making a pretty but practical practice board

By Deborah Pompano

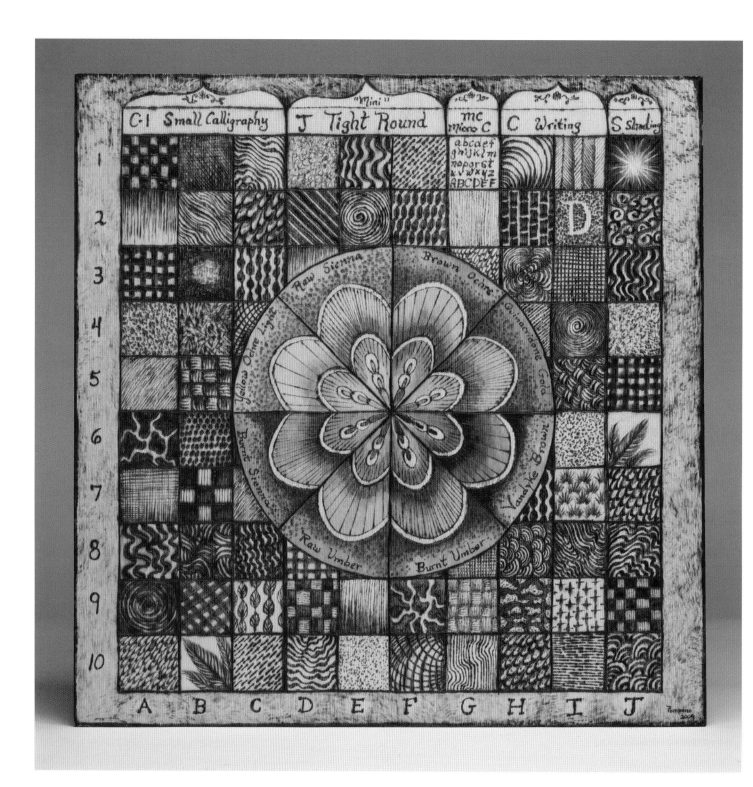

If you are new to pyrography, you're no doubt eager to try a project, but you may also be a little uncertain what your new machine can do. You may have a collection of pens or tips and some attractive patterns, but not know how to use one to make the other. The best place to start is with a practice board.

I designed this practice board to look like a crazy quilt, so it is attractive as well as functional. You can use it to experiment with various tips, practice specific patterns, play with texture, and even try some color tints commonly used to accent pyrography. The grid system will help you keep a record of what you did in each square.

The squares of my sampler are deliberately loose and imperfect. It's okay to have rough areas and inconsistencies in our work—it adds to the charm and handmade quality of the woodburnings. Woodburning has long been considered to be a rustic, natural type of folk art, so we can always claim that our errors are intended to add to the rustic quality! Be patient and tolerant with yourself in this learning stage; we often learn more from our mistakes than from our successes. Relax and have fun as you experiment.

The examples I've given for each square of the sampler are simply suggestions to guide you. Please feel free to discover and use variations on them or to experiment with your own lines, patterns, and textures in the sampler blocks. Be creative as you complete your own sampler.

Getting Started

Start with a scrap of wood (not your project board) and simply burn lines to get a feel for holding the pen and to test the effects of various temperatures. This isn't just an exercise for newcomers; it's always a good idea to test tips and practice strokes on scraps before starting any project to reduce the risk of spoiling your work. When you feel comfortable with the pen and the different heat settings, it's time to draw the sampler grid and experiment with your pens.

Enlarge or reduce the Crazy Quilt Sampler pattern to fit your wood, and then transfer the design to the wood using graphite transfer paper. You can use a ruler to guide the pen as you transfer the straight lines from the pattern. I lined up my pattern with the grain, so that the grain *runs vertically* from top to bottom. The direction of the grain lines will strongly affect the lines you burn.

Next, outline the squares with the corner of a writing tip. You can outline just a few blocks at a time or burn all of the lines at once. Although using a ruler when transferring the pattern is helpful, you do not need to use a ruler for this woodburning stage. Don't worry about making the woodburned outlines perfectly straight—once you have filled in all of the blocks, it will not matter if the lines are slightly wavy. You can make the lines medium dark for now. After you have completed all the blocks in the sampler and textured the edges, you can go back and darken all of the lines with the writing tip. Now, use the writing tip to label the rows numerically and alphabetically as shown.

Note: I use a Colwood Detailer woodburner with five types of fixed-tip pens: the Mini J, or tight round; the C-1, or small calligraphy; the S, or shading; the C, or writing; and the MC, or micro writing. You can use the tips that came with your burner; just compare them to the photos or descriptions here and use those that are similar. Of course you can also experiment with other types of tips to find your favorites.

Quilt sampler pattern
Enlarge at 200%

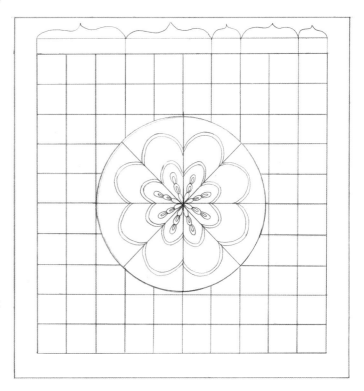

C-1 Small Calligraphy Tip

This extremely useful tip is actually three tips in one. When using the corner of the tip, it performs like a writing tip. When used with the wide edge held horizontally, it can make broad areas of shading. When held at a 45° angle to the wood and rotated between the thumb and fingers, it can be used as a calligraphy tip, creating gracefully curved thin and thick lines.

- **A-1 checkerboard.** Lightly draw guidelines to create a checkerboard pattern with evenly spaced squares. Using the entire wide edge of the tip, make the dark squares. Using the corner edge, draw the light vertical lines in each light square of the checkerboard. Use a knife to gently scrape areas that may burn too darkly.
- **A-2 parallel lines.** Use the corner edge of the tip to draw vertical lines from top to bottom in the square, close together. In the top half, go more slowly and use slightly more pressure to make the line darker. Lighten the line toward the bottom by stroking faster, with less pressure. Always pull the stroke toward you and then lightly lift off at the bottom of the stroke. This should create a lighter, thinner line toward the bottom of the square.
- **A-3 interwoven strokes.** Similar to large, thick crosshatching, this design will help you practice going across the wood grain. With the tip on its wide side edge, stroke horizontally in 5 or 6 stripes across the square. Repeat the motion vertically to create a criss-cross effect.
- **A-4 stippling (dots).** Stippling is the use of dots to create shadows, textures, and 3-D effects. Tap the corner edge of the tip on the wood at a 45° angle. Experiment with dots and short dashes on different heat settings, closer together or farther apart.
- **A-5 short strokes.** Position the wood so you can pull the pen strokes toward you. Make short or longer lines, slightly curved, going in the same direction, and slightly overlapping or askew, rather than strictly parallel. This technique is useful for fur lines, short grass, and hair. To make fur look natural, curve each stroke to follow the contours of the animal's body.
- **A-6 stone path.** Use the wide edge of the tip on high heat to create random shapes separated by thin unburned areas of wood.
- **A-7 fine crosshatch.** Crosshatching is two groups of parallel lines that are perpendicular to each other; it's a handy way to create shading, texture, shadows, and depth in your work. Turn the wood so you can pull the tip toward you.

- **A-8 curves.** Practicing curved lines will help you develop control and flexibility of the pen tip. As you progress through the curve, roll the pen between your thumb and fingers. Use the wide edge of the tip, and move it from side to side in a smooth motion, angling it as you make the turns.
- **A-9 concentric circles.** Begin by filling the four corners of the square with short, curved strokes, rotating the wood so the pen tip pulls toward you as you make the curved lines. After filling in the four corners, which creates a blank circle in the center, make short, curved connecting strokes, working toward the center. There is no need to try to draw the whole spiral all in one stroke.
- **A-10 small fish scales stroke.** Use the corner edge of the tip to draw this curved, hooked stroke. Holding the pen so the corner edge touches the wood, move the tip to the left, making the thinner line. Curve down and around the C-shaped hook, and then back to the right. On the C curve and back stroke, make the line wider by using the wide edge of the tip and holding the tip down longer.
- **B-1 triple crosshatch.** Use this pattern in the darkest shaded areas of your woodburnings to create depth and texture. On top of regular perpendicular crosshatching (as in A-7), add a layer of diagonal woodburned lines using the corner of the tip.
- **B-2 wavy, curved lines.** Roll the pen between your thumb and fingers, using the corner of the tip. Wavy lines are useful for depicting the grainy patterns of wood or the rippled patterns on water.
- **B-3 short, overlapped dashes.** Using the corner of the tip, make heavy layers of short dashes, leaving the inner circle lighter than the edges to create a 3-D effect.
- **B-4 random dashes with "tails".** Here's your chance to make blobs on purpose! Hit the wood hard with the tip corner and trail off lightly to make the tails. Turn the work as you go, and aim for a random pattern.
- **B-5 basket weave pattern.** A handy texturing pattern for filling blank areas on borders. Draw the horizontal and vertical guidelines lightly in pencil first. For more definition, darken the striped lines of each tiny basket weave square on one side only.
- **B-6 large dots.** Using the corner of the tip, experiment with raising and lowering the heat setting to intentionally create a light golden brown halo of "scorch" surrounding each dot.
- **B-7 nine block cross.** Make the dark squares from vertical lines burned close together on a high heat setting. Create the lighter squares with lightly burned lines drawn farther apart and on a lower heat setting.
- **B-8 curved line basket weave.** A random design of interesting curved lines.
- **B-9 diagonal crisscross.** Use the wide edge of the tip and make lengthwise lines from corner to corner.
- **B-10 feathers.** Position the wood upside-down and pull the strokes toward you. First, make three long,

slightly curved lines for the central quills of the three feathers. Beginning from the central lines, use the corner of the tip to make short, curved feather vane lines. Do not outline the feather edges.

- **C-1 wavy lines.** Similar to B-2, but with thicker and thinner lines; useful for depicting wood grain or water ripples. Use the corner edge of the tip but roll slightly to left and right, onto the wider edge, as you make the curves.
- **C-2 large fish scale.** Follow the instructions for square A-10. After drawing the scales, use the corner of the tip to make shaded parallel lines at the base of each "scale" to add depth and dimension.
- **C-3 wide-thin pattern.** Draw the shapes with the corner of the tip and fill them with parallel lines.
- **C-4 curved contour lines crosshatch.** Contour lines, made with the corner of the tip, follow the shape of the object—great for depicting rounded objects.
- **C-7 fur lines.** Make short, diagonal strokes with the corner of the tip.
- **C-8 wavy lines.** Gently roll the wide edge of the tip between your thumb and fingers as you pull the pen toward you.
- **C-9 leaf pattern.** This technique is similar to the feathers in B-10. Turn the board upside-down and pull the pen toward you. Outline the leaf shapes. Draw the central leaf veins. Make curved lines, gracefully radiating outward from the central vein to the leaf edge with the corner of the tip.
- **C-10 diagonal dashes.** Use the corner of the tip to make quick movements, setting the tip down and lifting off.

Mini J Tight Round Tip
The edge of the rounded tip of the Mini J allows you to easily make straight or curved lines in a tight radius, and it can also be laid flat on its side and used as a shader in tight spaces.

- **D-1 random squiggles.** Use the thin edge of the tip held at an 80° angle to the wood.
- **D-2 diagonal wide lines.** Hold the pen at a 45° angle to the wood and use the flat surface of the tip laid on its side.
- **D-3 vertical lines.** Draw from top to bottom using the thin edge of the tip.
- **D-8 crisscross lines.** Draw with the tip flat on its side.
- **D-9 checkerboard.** Make the vertical lines in the darker squares with the edge of the tip using higher heat and placing the lines closer together. Draw the horizontal lines in the lighter squares with lower heat and place the lines farther apart.

- **D-10 curved wavy lines.** Use the thin edge and the flat surface of the tip in each line by rotating the tip between your thumb and fingers as you move across the wood grain.
- **E-1 vertical wavy lines.** To create a halo effect of light golden "scorch," turn up the heat and make vertical lines while rolling the pen between your fingers so you alternate using the wide edge and thin edge of the tip.
- **E-2 spiral.** Using the thin edge of the tip and beginning at the four outer corners, first make thin, curved lines in each corner, which will create a blank circle in the middle. Then, rotating the wood, make short, curved connecting strokes until you reach the center.
- **E-9 vertical lines.** Pull the tip toward you, moving it more slowly at the bottom to darken the line.
- **E-10 stippling dots.** Hold the thin edge of the tip at an 80° to 90° angle to the wood and tap to create dots.
- **F-1 diagonal dashes with light gold "scorch" halo effect.** Turn up the heat a bit to get the halo effect.
- **F-2 leaf shapes.** Outline the shapes with the thin edge of the tip and fill in with the flat edge.
- **F-9 stone path.** Outline the shapes with the thin edge and fill in with the flat edge on a higher heat setting.
- **F-10 curved contour lines.** Use the thin edge of the tip.

MC Micro Writing Tip
This tip glides along the surface of the wood just like a fine ballpoint pen. It is useful for very fine details, including lettering, signatures, and shading.

- **G-1 alphabet.** Practice writing letters.
- **G-2 light vertical lines.** Draw lines from top to bottom.
- **G-3 fish scales.** Make a curved, hooked stroke.
- **G-8 fine crosshatch.** Draw horizontal and vertical lines to create a crosshatch pattern.
- **G-9 fine basket weave.** Alternate squares with vertical lines and squares with horizontal lines. Emphasize the thickness of the lines on one edge of each tiny square to create dimensionality.
- **G-10 wavy lines in random patterns.** This pattern is handy for depicting wood grain and water ripples.

C Writing Tip

The C writing tip is just like the Micro C tip except that it is larger and has more of a curved surface to work with.

- **H-1 curved contour lines.** Make these lines darker at the edge by going slower and using slightly more pressure. Keep the lines in the center area lighter.
- **H-2 brick pattern.** Outline the bricks first and then fill them with dark lines close together. If you accidentally burn too far into the light area between the bricks, gently scrape to lighten them.
- **H-3 semi-circles converging in the center.** This is a random pattern designed to help you practice curved lines.
- **H-4 diagonal lines.** Simple diagonal lines running from corner to corner.
- **H-7 wide-thin pattern.** Outline the shapes and fill them with dark lines close together.
- **H-8 overlapping waves.** An attractive pattern with curved, overlapped lines.
- **H-9 textured flagstone.** Outline the "flagstones" and stipple inside the shapes. Fill the dark areas between the stones with short, dark lines placed close together.
- **H-10 large fish scales.** Shade each "scale" with parallel lines at its base to indicate overlapping and create a sense of depth.
- **I-1 herringbone pattern.** A simple line pattern filled with short lines going in opposite directions.
- **I-2 your initial.** Lightly sketch your initial in pencil. Leave the inside area of the letter blank and surround it with stippling.
- **I-3 crosshatch.** A simple crosshatch pattern, useful for many applications.
- **I-4 spiral.** Begin by filling the four corners of the square with short, curved strokes, rotating the wood so you pull the pen tip toward you. Then, make short, curved connecting strokes, working toward the center from the outside of the circle. Don't try to draw the spiral line all in one stroke.
- **I-5 curved line basket weave.** Alternate two-strand and three-strand basket weave and use curved lines between the woven areas.
- **I-6 stippling dots.** Hold the tip at an 80° to 90° angle to the wood and tap.
- **I-7 grass clumps.** Turn the sampler upside-down and pull the tip toward you in short, curved strokes to create clumps of "grass."
- **I-8 wavy lines.** Move your whole hand and the pen tip in graceful curving motions.

- **I-9 random cross pattern.** Simply write with the woodburning tip as you would with a pen. Touch down lightly and lift off gently to prevent blobs.
- **I-10 horizontal broken dash lines.** Set the heat on medium low to prevent blobbing and scorching as you burn the short dashes.

S Shading Tip

The curved, flat edge of the shader can create a huge variety of effects and cover large areas of shading quickly and smoothly. Experiment with different heat settings.

- **J-1 star.** Using the flat, curved surface of the tip and rotating the wood as you work, pull shaded bands of woodburning from the outer edge of the square toward the center, leaving the center area lighter. Then, using a scraper, scrape rays of light coming from the central light area and extending into the dark shaded areas. This is very dramatic in night scenes.
- **J-2 random swirls.** Draw with the flat, curved surface of the shader.
- **J-3 wavy vertical lines.** Draw with the flat, curved surface of the tip.
- **J-4 stippling dots and dashes.** Hold the shader upside-down with the tip at an 80° to 90° angle to the wood and tap on the surface. Use a low heat setting to keep the effect light and delicate.
- **J-5 crisscross.** Create horizontal and vertical bands with the flat, curved surface of the shader.
- **J-6 soft feathers.** Turn the wood sideways so you can pull the tip toward you. Make the central quill line of each feather with the tip of the shader. Then, using the flat, curved surface of the tip, gently make curved lines to represent the feather vanes coming from the central quill line. Straight lines on feathers will look unnatural.
- **J-7 large fish scales.** Use the flat, curved surface to create curved, hooked shapes.
- **J-8 wavy lines.** Use the flat, curved surface of the shader and vary the pressure and the speed to get the dark and light effects in each line.
- **J-9 checkerboard pattern.** Make the darker squares with the flat, curved surface of the shader. Turn the tip upside-down to make the lighter squares with vertical lines. You can also draw the lines around each small square with the upside-down tip.
- **J-10 overlapping waves.** Use the flat, curved surface of the shader to draw the curved lines of the waves.

Finishing the Project

Give a more finished look to the piece by using the flat, curved surface of a shading tip to burn a dark border around the outer edge of the wood. I created an antiqued "burled" wood effect on the border of the sampler by lightly gliding the shader over the entire outer border area. Start at a low heat setting and slowly increase the temperature to achieve the level of darkness you desire in the border texture. If you burn some areas too darkly, rub them gently with a piece of sandpaper to lighten them.

When you finish the border, darken the outlines of each sampler square using a small calligraphy tip.

To prepare the central circle for the color exercise, use a writing tip to outline the eight wedges. Transfer and woodburn my flower pattern or create your own design, adding patterns and textures as desired. Write the names of the colors on the wedges as well. Mix the paints with water to create washes and apply them to the wedges. When thoroughly dry, spray the finished sampler with several coats of polyurethane.

Materials & Tools

MATERIALS:
- Basswood, 1" (25mm) thick:
 12" x 12" (305mm x 305mm)
- Scraps of basswood
- Acrylic paint: yellow ochre light,
 raw sienna, brown ochre,
 quinacridone gold, burnt sienna,
 raw umber, burnt umber,
 Van Dyke brown

TOOLS:
- Woodburner and pens or tips, such as
 Colwood: Mini J, or tight round; C-1, or
 small calligraphy; S, or shading; C, or
 writing; and MC, or micro writing
- Basic pyro kit (see page 101)
- Paintbrushes

The author used these products for the project. Substitute your choice of brands, tools, and materials as desired.

Pen Practice

If you're new to pyrography, you will need to get a feel for holding the pen and burning lines. Use a piece of scrap wood similar to your project piece. Different varieties of wood burn at different speeds and grain affects the burn, so you should practice every time you change wood. Be sure to practice with various tips, also.

Holding the Pen

How you hold the woodburning pen is a matter of personal preference; most people hold it like they would a pencil. Hold the pen lightly; squeezing too hard will make your fingers ache and your hand hot. Likewise, use light pressure. Instead of pushing down with the tip, experiment with temperature settings and hand speed until you can create a smooth line with a light touch. Finally, practice moving the pen, and be aware of how the cord moves, too. Keep the cord away from the hot tip.

Drawing Lines

Turn the temperature up and down as you draw, and watch the way the lines change colors. Most artists use medium settings and layer the color, which allows you to control the depth of color and avoid scorches.

Then, choose a medium setting and draw a series of straight and curved lines. Move the pen quickly and slowly. You'll notice that the lines are usually darker at the beginning of a line and lighter at the end, as the tip cools. Lines drawn quickly are lighter than lines drawn slowly.

Blobs or holes occur when you move the pen slowly as you touch down, or if you slow or pause mid-line. To avoid blobs, glide the pen smoothly at a consistent speed and lift off smoothly at the end of the line, like a hawk catching a fish or an airplane touching down and taking off.

With practice, you will learn to coordinate the speed of your hand with the temperature setting to create consistent burn depths and colors.

INDEX

Note: Page numbers in *italics* indicate projects and patterns. Page numbers in **bold** indicate contributor bios.